MW00575529

ILLUMINATION
FOR
CALLIGRAPHY

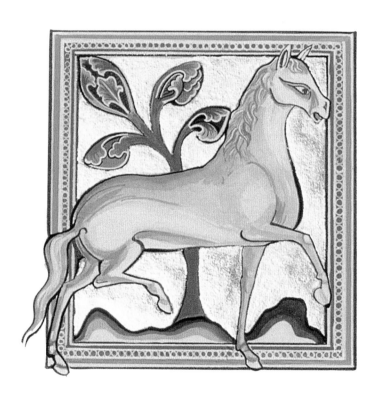

To my husband, Michael,
for his patience and
encouragement

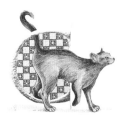

ILLUMINATION
FOR
CALLIGRAPHY

Janet Mehigan

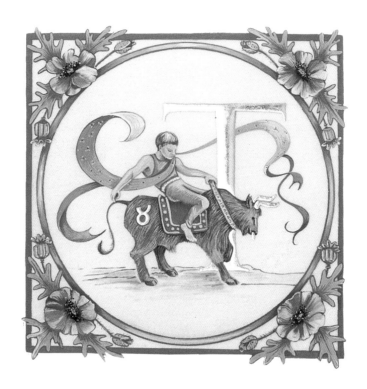

SEARCH PRESS

First published in Great Britain 2001

Search Press Limited
Wellwood, North Farm Road,
Tunbridge Wells, Kent TN2 3DR

Text copyright © Janet Mehigan 2001

Photographs by Search Press Studios
Photographs and design copyright © Search Press Ltd. 2001

All rights reserved. No part of this book, text, photographs or
illustrations may be reproduced or transmitted in any form or by
any means by print, photoprint, microfilm, microfiche,
photocopier, internet or in any way known or as yet unknown, or
stored in a retrieval system, without written permission obtained
beforehand from Search Press.

ISBN 0 85532 843 6

The Publishers and author can accept no responsibility for any
consequences arising from the information, advice or instructions
given in this publication.

Readers are permitted to reproduce any of the items/patterns in
this book for their personal use, or for the purposes of selling for
charity, free of charge and without the prior permission of the
Publishers. Any use of the items/patterns for commercial
purposes is not permitted without the prior permission of the
Publishers.

Suppliers

If you have difficulty in obtaining any of the materials and
equipment mentioned in this book, then please visit the Search
Press website for details of suppliers: www.searchpress.com

Alternatively, you can write to the Publishers at the address
above, for a current list of stockists, including firms which
operate a mail-order service.

Publishers' note

All the step-by-step photographs in this book feature the author,
Janet Mehigan, demonstrating the techniques of illumination.
No models have been used.

There is a reference to sable hair brushes in this book. It is the
publisher's custom to recommend synthetic materials as
substitutes for animal products wherever possible. There is a
large number of artificial fibre brushes available and these are
satisfactory substitutes for those made from natural fibres.

Printed in Spain by A.G. Elkar S. Coop, 48180 Loiu (Bizkaia)

Acknowledgements

I would like to thank all those at Search Press who made this book
possible: Roz Dace for her initial interest and encouragement
throughout its production; my editor Alison Howard; the late
Julie Wood to whom I am indebted for the book design and
layout, and Lotti de la Bédoyère for her skilful photography in
the difficult task of capturing the elusive shine of the gold.

Thank you to John Hardacre, Curator of Winchester Cathedral
Library, whose generously-given information, help and
enthusiasm added to my understanding and admiration of the
illumination contained in the magnificent Winchester Bible.

I would like to thank the British Library, London, for the use of
the historical examples and in particular Michelle P Brown,
Curator of Illuminated Manuscripts, for her interest and advice,
which I very much appreciated.

My thanks to the Bodleian Library, University of Oxford, for
permission to reproduce a copy of the horse from MS Ashmole
1511, folio 32v.

Thanks also to Keith Wigglesworth at L. Cornelissen and Son
Limited, London, for the loan of gilding materials, and to William
Cowley Vellum and Parchment Works, at Newport Pagnell, for
kindly supplying samples of vellum and parchment.

My thanks to fellow enthusiasts who contributed to the
Gallery, providing inspiration and diversity for future
illumination designs. I only wish there had been space to include
more examples.

Lastly, I would sincerely like to thank all my past teachers who
have made calligraphy and illumination such a joy and also my
own students whose interest and progress ensures my constant
enthusiasm and love of the subject.

Page 1 *Stretched vellum miniature horse from MS
Ashmole 1511, folio 32v (see project on page 63).*

Page 2 *Cat with gilded C with diaper patterning
(see project on page 68).*

Page 3 *The astrological or Zodiac sign Taurus
(see project on page 81).*

Contents

Foreword

I was delighted to be able to write about a subject that I enjoy so much. It gives me the opportunity of sharing some of the ideas, possibilities and pleasures of working with paint and gold.

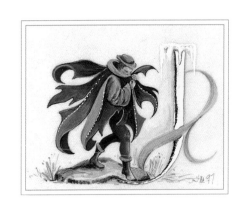

If you have never attempted calligraphy, drawing, painting or illuminating, this book may seem a little daunting, as may the idea of creating original designs. I find my students are worried by the prospect of using bright colours and 'real gold', and there are cries of : "I can't draw", "I'm not an artist", or "My work isn't good enough for gilding".

My advice is to take it one step at a time: once started, you are usually 'hooked'. When you have learned about the materials and tools, you will be amazed how easy the techniques are, and surprised by what can be achieved in a short time.

Janet Mehigan

Above and right: Miniatures on stretched vellum illustrate the Edmund Spenser poem 'The Pageant of the Seasons and the Months'. Designed and painted by the author.

Introduction

History

Decorated and illuminated manuscripts have always held a fascination for me. Their pages are so rich in ornamentation, with wonderful interlacing patterns, motifs and designs which are often extremely intricate and painted in luminous colours, all exquisitely created by artists and illuminators hundreds of years ago. Although the books and manuscripts have been in existence since medieval times, many of the illustrations are as radiant as when they were originally painted, and the gold looks as though it was polished yesterday. Their creators were among the best artists of their day.

Early manuscripts are full of symbolism. Some contain the stories of the text as miniature illustrations within painted letters. Later manuscripts such as the Books of Hours yield a wealth of fascinating information, and present a valuable insight into the social behaviour, philosophy and fashion of people living in those historical periods. Still more show the endeavours of everyday life, and the flora and fauna with which the population was familiar.

Understanding how these illuminated pages were created enhances their appeal for me. It is really exciting to work with the materials that these accomplished scribes and illuminators so painstakingly developed.

The earliest example of the *codex* – a manuscript in book form – was written on papyrus in the late first or second centuries AD. By the 4th Century, vellum books had replaced papyrus rolls and codices. Early books consisted of lines of continuous writing in small capitals; there were rarely divisions in the text for paragraphs or chapters. The first use of paragraphs was shown by simple line breaks, then by using a larger capital as the first letter of a line. When *minuscules* – lower-case letters – were developed for the main text, large capitals based on Roman or Uncial letter forms (usually coloured red and often decorative) were used to denote the beginnings of paragraphs and verses. These letters are called *Versals*.

A Versal in its simplest form was a pen-drawn letter based on the Roman Imperial Capital, quickly-executed and deftly-filled with colour, usually red but often blue or green. When used as headings or half-pages of capitals Versals are called *display capitals* (see **Bosworth Psalter** opposite). A hierarchy often applied to scripts used on important pages, beginning with pen-drawn Roman Display Capitals at the top and an enlarged decorative initial letter. Uncial and Rustic – of less importance and diminished in size – were used further down the page.

The art of illumination began with decorative initial letters, which over time became more elaborate and extended into border decoration, historiated letters – those which contain within their design figures or scenes linked to the story – and miniature paintings. Books were decorated, illustrated and illuminated for much the same reasons we illustrate books today: to enable the reader to understand the text. The use of colour enlivens the written word, and gave the missionaries of the 7th and 8th centuries the opportunity both to explain the stories and visually to enhance the religious message which they travelled throughout Europe preaching. Expensive pigments and gold were used in honour of the religious content.

Bosworth Psalter
MS37517, folio 33
Christchurch, Canterbury
late 10th Century

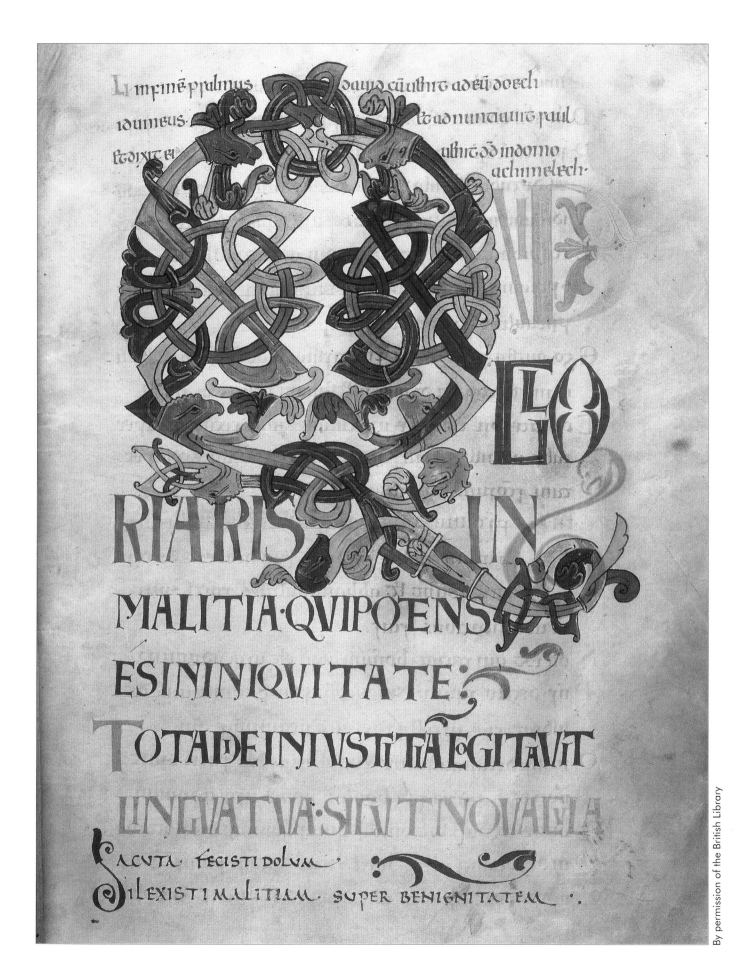

In finē ppalmus dauid cū usthit ad eū doech
idumeus. teadnūntiauit paul
et dixit ei usthit ad indomo
achimelech.

QUID GLORIARIS IN
MALITIA QUI POTENS
ES IN INIQUITATE:
TOTA DIE INIUSTITIAE COGITAVIT
LINGUA TUA:SICUT NOVAELA
cuta fecisti dolum
dilexisti malitiam super benignitatem.

By permission of the British Library

The Lindisfarne Gospels

The Lindisfarne Gospels originated in Northumberland between 698 AD and 721 AD. The book was transcribed and decorated entirely by one man, Eadfrith – later Bishop of Lindisfarne Church – who wrote it 'for God and St Cuthbert' around a century after Christianity had been reintroduced into England.

The decorative spirals, circles, interlacing knotwork and zoomorphic forms used within the large initial letters are similar to those found in pre-Christian Celtic metal and jewellery design. The decoration used was symbolic and stylised and the display capitals angular, probably influenced by the Germanic Runic alphabet. The design of each fully-illustrated page is well-considered, and spaces are filled with countless red dots, which also surround the display capitals and initial letters of the main text.

The range of colours used in the Lindisfarne Gospels was that of the time, and comprised pigments made with white and red lead; verdigris (cool green); yellow ochre; kermes (a red colour obtained from Mediterranean insects); a range of pinks and purples from folium (turnsole plant) and the rich, expensive blue derived from grinding the semi-precious stone lapis lazuli. Other minerals used were malachite, from copper ore (green) and azurite from basic copper carbonate (blue). There are only a few tiny areas of gold in the Gospels; the highly-poisonous yellow orpiment (sulphide of arsenic) which looked like gold, was used as an alternative. Colours at that time would have been bound to the page by mixing them with egg white (glair), gelatine gum made from boiling parchment skin, or fish glue.

Note In ecclesiastical calendars important feast days and saints' days were coloured in red, hence the term Red Letter Day.

9th and 10th centuries AD

Many 9th- and 10th-century designs showed continental influences such as the classical acanthus leaf decoration, though the interlace patterns of Anglo-Saxon art remained in the manuscript designs of Canterbury and Winchester.

In the *Bosworth Psalter* (shown on the previous page) Roman Versals are drawn with a pen and filled with colour in alternating reds and blue. These 'display' capitals diminish in size down the page, ending with two lines of Rustics. The Anglo-Saxon interlace pattern is retained in the letter Q, though the curling leaf endings are of Mediterranean and Carolingian (from the court of Charlemagne) design. Simple tendril motifs are used on the second and fifth line from the bottom to ensure a balanced page layout.

The Lindisfarne Gospels
The beginning of
St Matthew's Gospel,
folio 27

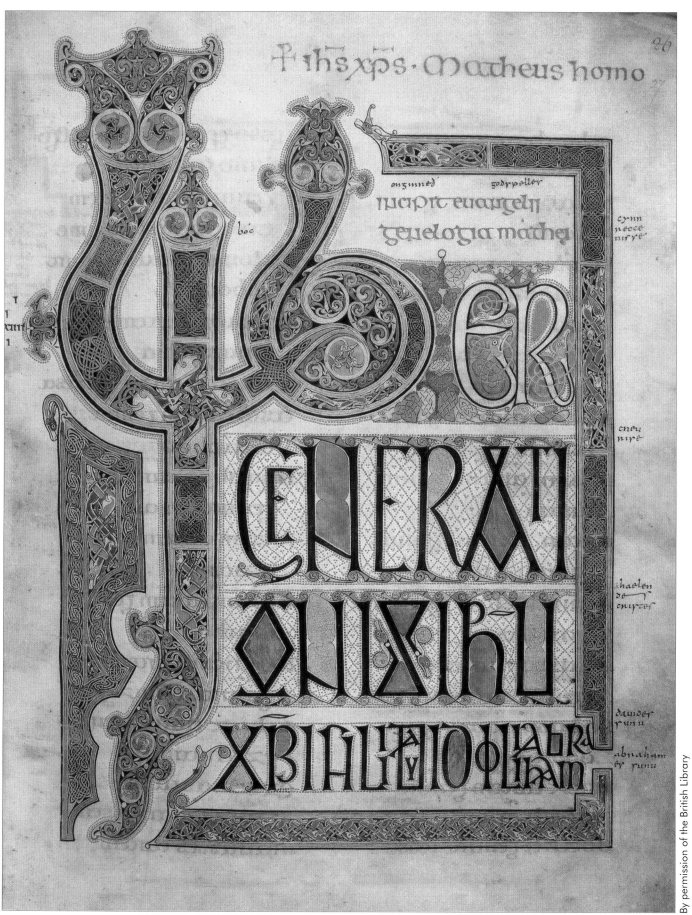

By permission of the British Library

13

Romanesque

Extensive travel by members of the church meant that from the late 10th to the 12th centuries, decorated letters showed many influences from France and Germany, classical designs from ancient Rome and Byzantium (later Constantinople, now Istanbul) as well as the Winchester and Canterbury Scriptoria. Some letter forms were simple in execution, with small protruding leaf extensions, while others contained intertwining acanthus leaves on architectural structures which formed the borders of the pages. By the 12th Century human, animal and plant forms were included, richly decorated in gold and colour. The historiated letter, containing a narrative scene relating to the text, became more popular during this period.

The Winchester Bible, which dates from between 1160 and 1175 AD, is a stunning example of 12th-Century English illumination, with fine examples of historiated initials and coloured Versals. Its large size (a single page is 583 x 396mm or 23 x 15¾in) shows it was intended for display. The text was written almost entirely by one scribe in a script derived from Carolingian, but beginning to show the angularity of the Gothic style.

The display scripts and single Versals throughout the text are based on *Uncial* and *Square Capitals,* and are coloured alternately in red, blue and green with some letters embellished with simple decoration. The impressive initial letters and miniatures in this Bible are attributed to six different illuminators (Masters), each of whom used gold and rare Lapis Lazuli lavishly. The work of these unknown scribes is so distinctive that each has been given an individual 'name' by those who have studied their artistry. Many of the historiated initial letters fill the length of the page and are richly gilded and intricately painted. The decoration was never quite completed, but this is not without its compensation: there are fine examples of unfinished work at every phase of execution, from the drawing to each stage of gilding and painting. This has given historians a unique insight into the production processes involved.

> ***Note*** *Historiated letters are those which contain within their design figures or scenes linked to the story of the text.*

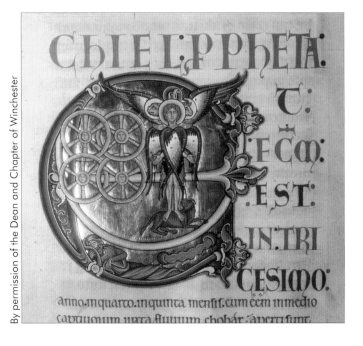

By permission of the Dean and Chapter of Winchester

The Winchester Bible
Initial E from the Book of Ezechiel, folio 172

The vision of Ezechiel includes a tetramorph with four heads symbolising the four evangelists. The Versal display capitals, showing simple extensions, alternate in red and blue.

Master of the Morgan Leaf

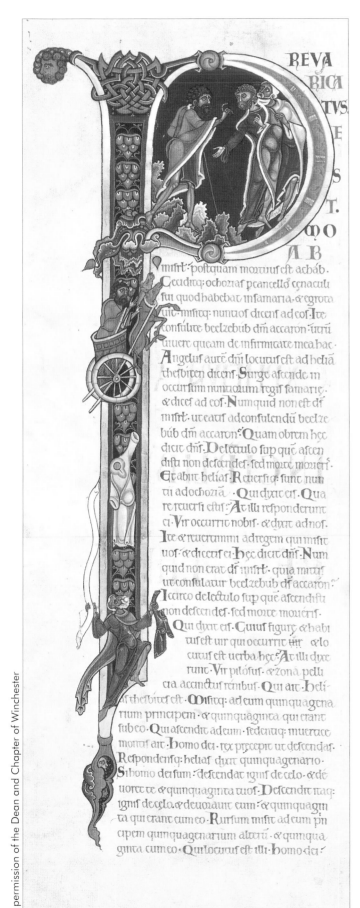

By permission of the Dean and Chapter of Winchester

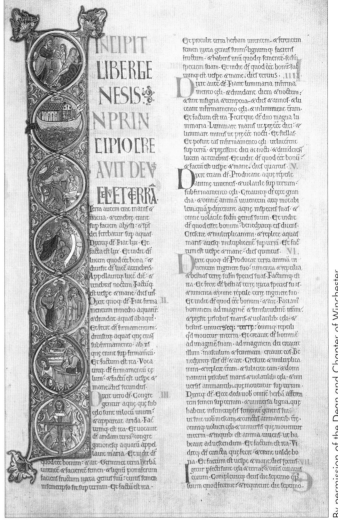

By permission of the Dean and Chapter of Winchester

The Winchester Bible

Above: The initial letter I from the Book of Genesis, folio 5, runs almost the length of the page. Each of its seven roundels contains a miniature showing man from creation to redemption: the creation of Eve; the Flood; the sacrifice of Isaac; Moses receiving the tablets of Law; Samuel anointing David; the Nativity; the Last Judgement.

The gold is laid on a cushion of gesso and burnished to a shine. The beautiful Versals alternate in colour down the page; the colours of the display Versals are varied line by line. 'Incipit Liber Genesis' ends on the third line with a small decoration, enhancing the layout of the block of capitals.

Master of the Genesis Initial

Left: The initial letter P from the second book of Kings, folio 120v. Elijah consulted by the messengers of Ahaziar and taken up in the chariot of fire, casts his mantle to Elisha.

Master of the Leaping Figures

Middle Ages

From the early Gothic period (c. 1200 AD) the rise of universities and learning meant that book production and illumination was no longer exclusively in the domain of the Church and monastic scriptoria. Professional scribes and artists set up workshops and guilds in the major cities of Canterbury, Winchester, Oxford, York, Bologna and Paris to supply the increasing demand for books on philosophy, medicine and poetry as well as legal and religious volumes. Monastic scribes continued their *opus dei* (work of God) in their scriptoria, collaborating with lay artists and craftspeople to produce books. The most popular were *Psalters* and *Books of Hours*. A Book of Hours is a compendium of devotional texts, psalms and prayer, reflecting the monastic divine office, which would be read quietly in private.

The Gothic period produced illuminated books which contained a diverse mixture of fantasy and realism. Flowers and plants decorated the Versal letters and pages were adorned with animals painted in bright colours with added white highlighting and shading to create form and a three-dimensional effect. In the later Middle Ages the nobility – emperors, dukes and wealthy merchants – commissioned books for their personal libraries, and devotional books and Psalters for their wives and relatives.

By 1400 AD illustration and illumination was in the form of small miniature paintings depicting the artist's environment, buildings and medieval clothing. Intricate diaper patterns, chequers and gold filigree adorned the letters and miniatures; ivy leaf borders and tendrils framed the text.

Versal letters became distorted, their thicker strokes extended and filled with simple but effective designs in white added with a fine brush or pen. These Versals are known as *Lombardic capitals*. Both coloured and gilded initials could be found in abundance throughout the text.

With the Renaissance (c. 1350 – 1500 AD) and the return to classical learning, decoration became realistic and representational. The illustrations began to reflect the styles of the classical painters of the period, but as miniatures. Many of the initial letters and Versals had the graceful proportions and sculptured appearance of the Imperial Roman capitals. With the invention of the printing press and the use of paper the speed of book production increased; the scribe and illuminator were unable to compete, and their livelihoods diminished. The Arts and Crafts Movement of the late 19th Century – and the subsequent research and teaching of Edward Johnston and his pupils – initiated a revival of medieval illumination which has lasted into the 21st Century.

The Luttrell Psalter
folio 182

Written and illuminated for Sir Geoffrey Luttrell, c.1340, with illustrations which are a mixture of biblical scenes and everyday medieval life, showing both realism and fantasy. The illustrations and the decorative initials are full of intricate detail. The illustrator had great imagination and a wonderful sense of humour.

no: domine deus meus magnifi
catus es uehementer.

Confessionem ⁊ decorem induisti:
amictus lumine sicut uestimento.

Extendens celum sicut pellem :
qui tegis aquis superiora eius.

Qui ponis nubem ascensum tuū:
qui ambulas super pennas uen
torum

Qui facis angelos tuos spiritus:
⁊ ministros tuos ignem urentem.

Qui fundasti terram super stabi
litatem suam: non inclinabitur
in seculum seculi.

By permission of the British Library

Materials

Over the years, I have collected a wide range of different materials, but you can start with just a few essential items. To begin with you will need only pencils, paper, inks, paints and brushes (see pages 44–45) plus equipment for cutting and measuring. Add extra items gradually as you become more experienced.

Basic equipment

1 **T-square** (parallel rule) for accurate line ruling.

2 **Set square** to measure angles. I use a 45 degree and a 30/60 degree set square.

3 **Rule** for measuring designs.

4 **Metal rule** or **straight edge** to use when cutting materials.

5 **Cutting board** (optional as thick card can be used).

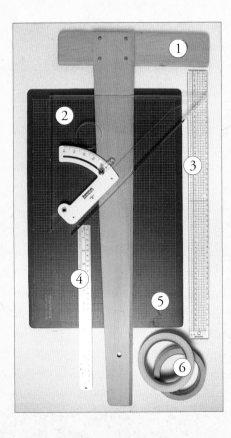

6 **Clear tape** and **masking tape** to secure designs.

7 **Red acrylic ink** and **black Indian ink** to outline pencil designs before painting.

8 **Absorbent paper** to mop up spills.

9 **Dip pens** to ink in designs.

10 **Nibs** for lettering. Many sizes and shapes are available.

11 **Reservoirs** to attach to the square-edge nibs so more ink or paint can be held.

12 **Ruling pen** used to draw lines when filled with liquid colour.

13 **Technical pens** for drawing inked lines (optional).

14 **Ink compasses** for drawing circles in ink or paint.

15 **Scissors** used to cut and trim designs.

16 **Scalpels** with different blades to cut and trim tape or designs.

17 **Springbow** dividers for measuring equal distances.

18 **Pencil sharpener** to keep pencils sharp for accurate line drawings.

19 **Eraser** for erasing large areas or lines.

20 **Pencil erasers** for erasing small areas or lines (optional).

21 **Coloured pencils** for sketching designs.

22 **Pencil compasses** used for drawing circles.

23 **Leads** used in a propelling pencil. HB is easy to erase; 2H (optional) is useful for tracing designs.

24 **Propelling pencil** can be used instead of a pencil to trace and transfer designs.

25 **Pencils** HB is used for sketching and line drawing; 2H is used to trace designs.

Drawing board (not illustrated). This is needed for writing with a pen but not for painting or illumination. Various sizes are available but a flat board about 41 x 58cm (16 x 23in) should be adequate. When writing, prop it up against the table at an angle of about 45 degrees with the lower end resting in your lap.

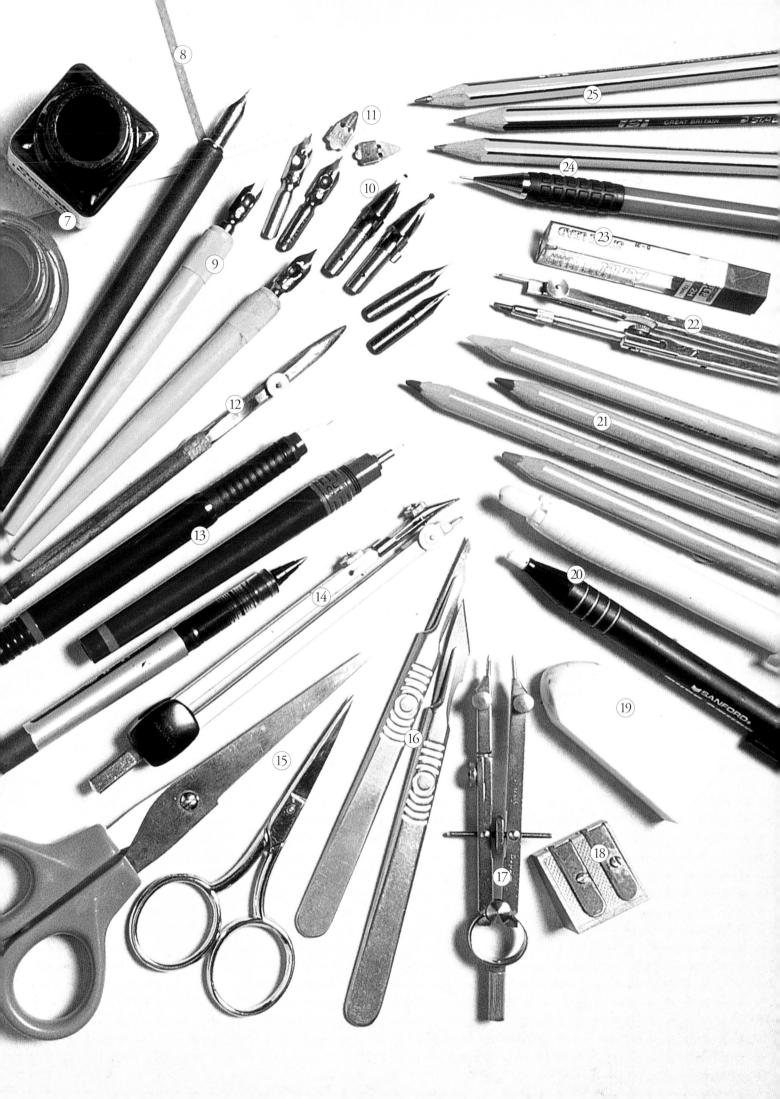

Papers and boards

Any work is improved by using the best materials, and calligraphy and illumination are no exception. Your choice of materials will be determined by how much you wish to spend and what you want to make. Use the best you can afford. For your first project, a good-quality, smooth paper is best. For decorative initials, small miniatures and illuminations, you may wish to choose the traditional material: vellum (skin).

During the learning process, most of your work will be on paper. Beginners may be confused about which paper to buy, and it is good practice gradually to build a file of different samples so you become familiar with what is available. Small pen and paint tests on each will help you to understand the individual qualities of different papers.

Paper weight (thickness) is measured in grams per square metre (gsm or gm^2), or pounds per ream (lb). A pack of 500 sheets is a ream. The lower the number, the lighter or thinner the paper. A sheet of 190gsm (90lb) will therefore be thinner than one of 300gsm (140lb).

The highest-quality papers are watercolour papers made from cotton linters – fibres which are too short to spin into thread. Paper fibre used to come from cotton or linen rags (hence the term 'rag') but these are not so plentiful today. These papers are strong as the fibres knit randomly when they are formed. Less-expensive paper is made from a mixture of cellulose (often wood pulp) and rag. Newsprint and the cheapest cartridge paper is made from wood pulp. Chemicals used to break down the wood fibre give the paper a high acid content, which causes discolouration as it ages.

For detailed work, smooth paper is best as it will accept water when you paint your design, or glue which is required for gilding. The fine, detailed work of the miniaturist or illuminator requires a 300gsm (140lb) hot-pressed watercolour paper. I use Waterford paper, but other types of watercolour paper can be used.

> **Note** All paper is sized to prevent it from being too absorbent, like blotting paper. Papers which are internally-sized (during the making process) have a soft surface and are fairly absorbent. Most paper is surface-sized (tub-sized) after it has been made, usually with traditional gelatine size. Surface-sizing makes the paper strong, shiny and resilient; the paint sits on the surface so mistakes can be removed more easily. Some papers are both internally-sized and surface-sized (tub-sized).

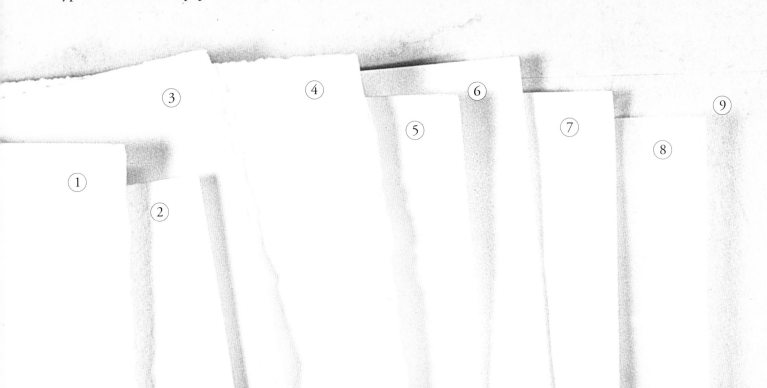

Watercolour paper There are three surfaces: hot-pressed (HP), cold-pressed (CP or NOT) and Rough. HP paper has a smooth surface, originally produced by passing it through hot rollers or plates, and is preferred by calligraphers, miniaturists and illuminators. CP or NOT has light pressure applied by cold rollers to minimise the surface texture and is the usual choice of watercolour painters. Rough paper is allowed to dry naturally and retains all its textural, uneven qualities. Its use for illumination is limited, but it gives exciting results when a large pen is used, and is a wonderful textural paper for watercolour painting.

Handmade paper is available from good art stores or specialist shops, in many surface textures and colours. The mould leaves four deckle (rough-finished) edges.

Mould-made paper looks like handmade paper, but sheets are individually made by machine. It has two deckle edges.

Machine-made paper is made in a continuous length on rollers, then cut into sheets by machine.

Line and wash board is good-quality watercolour paper with a board backing. It is expensive but useful when using wet-into-wet techniques.

Pastel paper is machine made with a smooth side and a textured reverse. It is available in many useful colours and is ideal for books and cards.

Cartridge paper is useful for beginners, but as the techniques become more familiar, you should use HP watercolour paper.

Photocopy paper is thin HP paper and is ideal for roughs, visuals or design ideas as it can be used like layout paper.

Layout paper is translucent with a smooth surface, and is used by designers for their first visuals or rough drawings. It is the most suitable practice paper for calligraphers, and it can be used instead of tracing paper.

Tracing paper is transparent and is used to refine any drawings. It is also used when transferring a design to finished paper.

Glassine paper is also called crystal parchment paper. It is used to protect gold when gilding, as gold does not readily stick to it. It can also be used to protect work in progress and finished artwork.

1 CP (NOT) 300gsm (140lb)

2 CP (NOT) 190gsm (90lb)

3 Rough

4 HP 300gsm (140lb)

5 Cartridge paper

6 Photocopy paper

7 Layout paper

8 Tracing paper

9 Glassine paper

10 Pastel papers

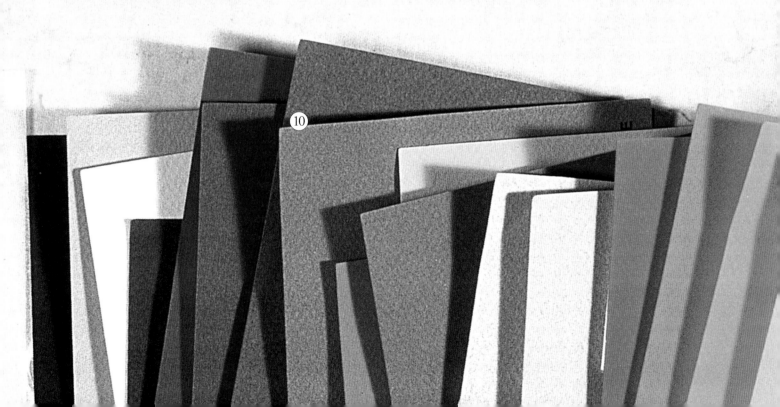

Vellum and parchment

Animal skin has been used for more than two thousand years. Many types, in different textures and colours, are available; vellum and parchment are the most commonly used.

Strictly speaking, vellum is calfskin and parchment is sheep skin, though these terms are often used to mean either. Skins are prepared by soaking in vats of lime to remove the hair, then they are stretched taut on frames and scraped clean with a lunar knife (a knife with a large semi-circular blade). When dry, they are cut from the frame, rolled and stored. It is more economical in the long run to buy a whole skin, but to avoid a high initial outlay you may prefer to buy a small piece.

For small decorated initial letters or miniatures, offcuts are ideal. These are pieces trimmed from the whole skin when the standard sizes are cut. Skin has a 'hair' side (outer surface) and a 'flesh' side which looks waxy and smoother. The 'hair' side is better for writing, as the 'flesh' side is often more greasy.

Calfskin manuscript vellum Prepared on both sides, this is the finest skin for writing and illumination.

Classic calfskin vellum is more coloured and is prepared on the hair side only. The variety of skin markings make it a good choice for individual works of character.

Kelmscott vellum is smooth on both sides. It is ideal for painting and illuminating but not for writing.

Other choices are: **slunk vellum** (not illustrated) which is so thin it is almost transparent; **goatskin vellum** which is thicker and slightly coarser, with wider colour variations and a characteristic dimpled texture on the hair side, and **sheepskin parchment**, which is rather thin for heavy gilding and can be greasy. Try small pieces of each so that you become familiar with their characteristics.

The manufacturer prepares the skin but it usually requires further preparation. Grease must be removed with pounce, an abrasive powder available from specialist suppliers – see note on right. If the skin is fine and not too greasy, minimal preparation is needed; over-preparation will make it difficult to push the paint into the nap with the brush. When you have finished rubbing in the pounce, brush any surplus onto a clean piece of paper and return it to its container for re-use.

For writing, the nap needs further treatment so the pen will 'bite'. Rub the areas which will be written on with fine sandpaper (350–400 grade) until the surface looks like very fine suede. Dust with fine gum sandarac powder, which will make the writing crisper. Brush off excess. Do not touch the prepared area with your hands, as they will deposit grease.

> *Note* Take care when you are using gum sandarac powder. It may cause an allergic reaction.

> *Note* Surplus grease on skins must be removed with pounce, a mixture of two parts ground pumice powder and one part ground cuttlefish bone powder. Grind the correct amounts to a fine powder using a pestle and mortar and store in a jar ready for use. With cotton wool or a scrap of vellum, rub the pounce gently into the skin, using circular movements.

1 *Natural goatskin vellum*

2 & 3 *White goatskin vellum*

4 *Classic calfskin vellum*

5 *Manuscript vellum (calfskin)*

6 *Sheepskin parchment*

7 *Dark classic vellum*

8 *Kelmscott vellum (calfskin)*

9 *Manuscript vellum (calfskin)*

10 *Offcuts of vellum*

11 *Whole skin showing edges*

12 *Pounce (pumice) powder*

13 *Brush for removing excess pounce*

14 *Cotton wool for rubbing vellum with pounce*

15 *Sandpaper, wrapped round block of wood to ensure even pressure when sanding skin*

16 *Fine sandpaper*

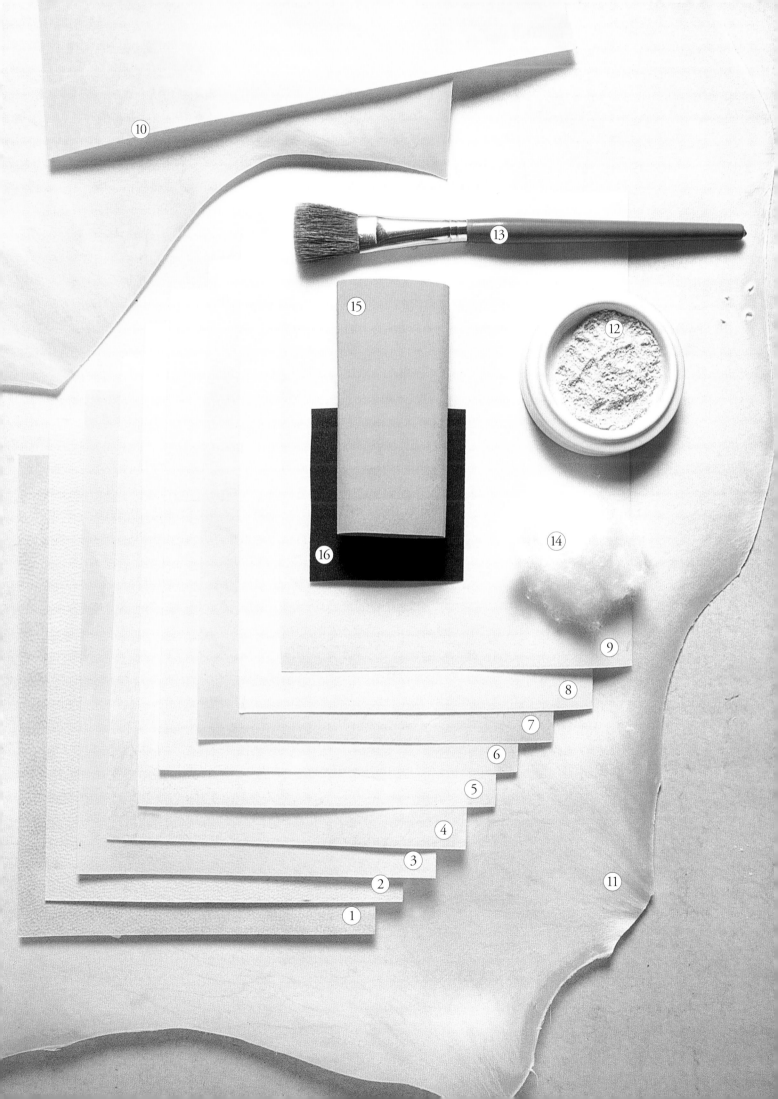

Design

Any form of design can be used to illustrate, decorate and illuminate, from geometric or abstract shapes to detailed drawings depicting objects, animals or flowers. The art of illumination demands a liaison between hand, eye and mind, but if you have already done some calligraphy this should not be too difficult. The novice may lack confidence, but simply needs to observe, learn and practise the techniques.

Ideas for design can be found everywhere: in magazines and books and on fabrics, wallpaper, wrapping paper and cards. Before throwing away packaging, or that worn dress or old patterned tie, investigate its design potential. Take a snippet and paste it into a scrapbook for future inspiration.

Become aware of your surroundings and observe them carefully. How does a branch grow? You will see that where it joins the main trunk it is thicker. Look at the way buds join a stem; the same thing occurs. Study colours carefully and see how the basic colour of a flower often permeates the leaves. The leaves of dark red flowers often have a hint of red; the leaves of lavender are blue-green or purple-green. Take a flower to pieces and look at the shape of the petals, stamens and stems.

When studying small objects, pick them up, turn them round and feel their shape and texture. If an object is large, walk round it and look at it from all angles. If you really look, texture and rhythm is everywhere. All this knowledge is really important and time spent observing natural things can never be wasted.

Even if you lack confidence in your own abilities, there are many ways to produce drawings. When you have mastered the basic principles of mixing paint and applying colour correctly you will soon discover the joys of creating your own designs for cards, small gifts and books.

Any form of design can be used to illustrate, decorate and illuminate, including geometric or abstract shapes or detailed drawings depicting objects, animals or flowers. One of the patterns opposite is used here with a gilded letter.

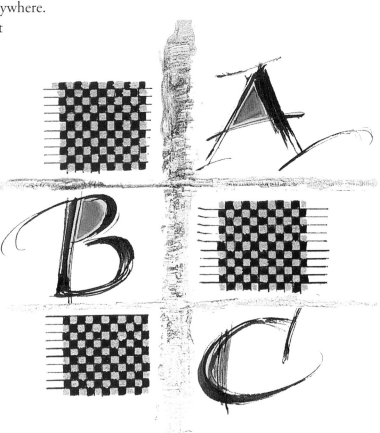

The patterns below have been developed from the reflections on the windows of the building in the centre of the photograph opposite. The smaller pattern has been adapted and used in the alphabet design on the right.

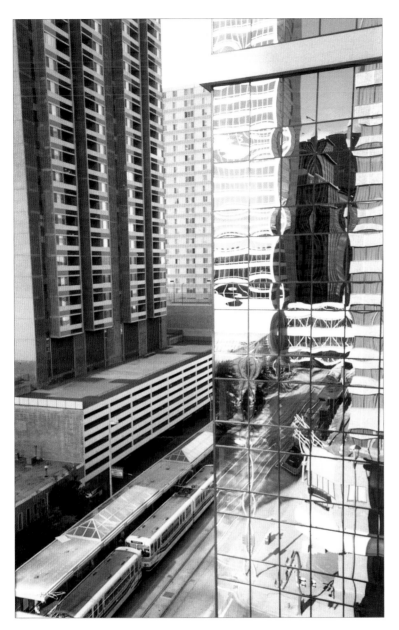

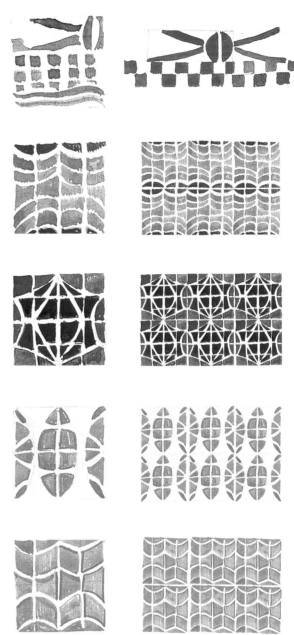

This photograph showing tall buildings in Calgary, Canada, offers excellent design potential. The design ideas on the right of the photo were inspired by distorted patterns in the windows – see if you can find them. Far right, the patterns have been developed still further.

A step further: the parallels of the letter E have been distorted as though the letter was reflected in the glass building, transforming its shape.

This shape is based on the reflection of a tree distorted by the glass. Repeating it forms a pattern.

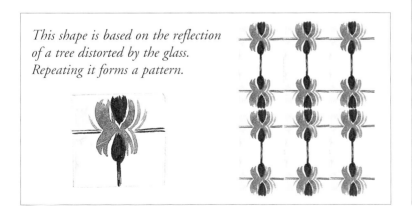

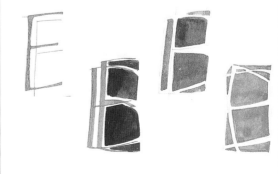

Designing from nature

Nature is a wonderful source of inspiration for design. Use natural objects or plants to enrich your powers of observation and then simplify the structure by drawing only what is required for your design.

Plants naturally have an ordered pattern of growth; leaves grow at regular intervals, either as pairs or growing alternately around the stem. The largest leaves are usually at the base of the plant with the newest and smallest leaves at the top creating a triangular shape. Pictures can be traced and details minimised (for tracing method see page 46).

Rosebay Willowherb seed head

This is a wonderful subject. Look carefully at the structure of the plant in the photograph below. The unripe green seed pods at the top are straight and tightly closed. Riper pods further down the stem have burst into three parts, dispersed their seeds and curled.

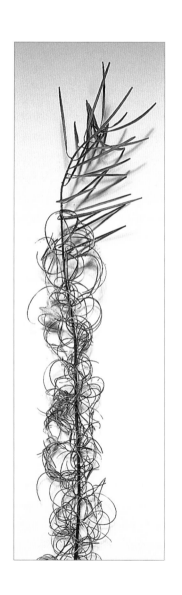

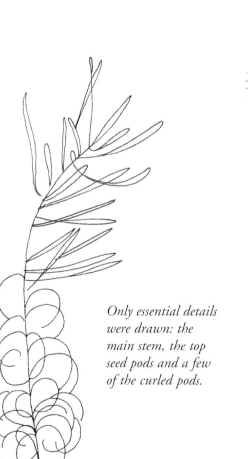

Only essential details were drawn: the main stem, the top seed pods and a few of the curled pods.

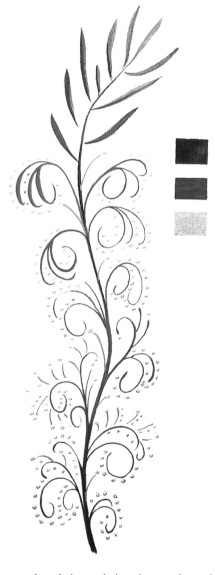

The drawing was traced and the curled pods transformed into a stylised pattern which was painted on watercolour paper. Gold gouache 'dotted' round the pods represents the seeds. The original plant has become the design source. Colours used are oxide of chromium, alizarin red and gold.

Vine

The process of drawing and painting the plant creates an awareness of form and structure and is about *real* observation. How many lobes on the leaves? Are they smooth or serrated? Do the leaf stems thicken as they reach the main stem? Do the leaves grow in pairs or do they alternate? What colours should I use?

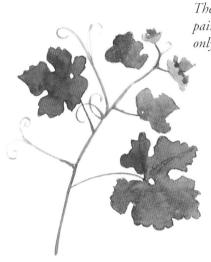

The plant was drawn and painted in watercolour, showing only some of the leaves.

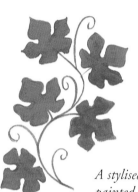

A stylised version of the painted plant study.

A simple version of a leaf was drawn, traced and repeated.

One traced leaf was repeated and painted in red and green.

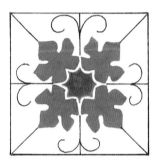

Tendrils have been added to traced leaves painted in red gouache. The centre is painted gold and a box surrounds the design.

This repeat design is based on the stylised study, with red, green and blue leaves dotted with white gouache, and a gold border enclosed by a black line.

Designing from history

Museums provide a wealth of ideas and visual inspiration. This Lombardic letter B – adapted from a 14th-century French manuscript – is typical of Gothic illuminated letters of the period, with white highlighting and a spiral of ivy leaves inside. Trailing and climbing plants produce moving elegant shapes and ivy, which symbolises everlasting life, was often used in designs.

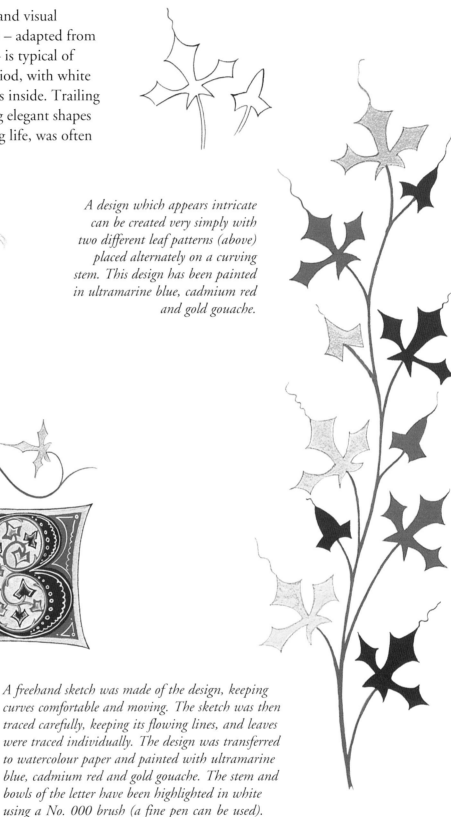

A design which appears intricate can be created very simply with two different leaf patterns (above) placed alternately on a curving stem. This design has been painted in ultramarine blue, cadmium red and gold gouache.

A freehand sketch was made of the design, keeping curves comfortable and moving. The sketch was then traced carefully, keeping its flowing lines, and leaves were traced individually. The design was transferred to watercolour paper and painted with ultramarine blue, cadmium red and gold gouache. The stem and bowls of the letter have been highlighted in white using a No. 000 brush (a fine pen can be used).

Transferring designs

Tracing paper is invaluable in the designing process, as it can be used to transfer light, accurate drawings to paper or vellum. The initial design – however rough – can be drawn on layout paper and different ideas incorporated as they come to mind.

At this stage, you need to give the drawing a 'feel', taking too much care can lead to a dull, lifeless image. Make as many scribbles as you like as only the lines needed will be transferred to the tracing paper. Small, separate tracings can be made of different areas and moved around until you arrive at a final image. I often work with several tracings piled on top of each other; rearranged, they form a composite picture from which I can eventually choose a motif.

This method allows easy addition and subtraction of ideas and I can see the finished version before my final draft. When you have selected an image, stick the tracings together with clear tape, then overlay a large sheet of clean tracing paper and draw the final image (see pages 46–47 for step-by-step method).

If this sounds too complicated, a photocopier can be used. Some books carry copyright-free designs: pictures or images can be reduced or enlarged onto paper, from which a final design can be traced and transferred to paper or vellum.

Both tracing and photocopying work well and are far easier than working on either a single sheet of paper or the actual design, when you may find yourself erasing unwanted lines constantly. Do not discard traced drawings as they can be used again in different positions; for example, border designs can be repeats of one drawing, or you may want to combine the images differently.

Tracing paper can also be used when you are deciding on colours. If you are unsure about how one colour looks against another, paint the second colour on tracing paper and compare them. A sheet of transparent acetate can be used instead, and has the advantage of being washable and reusable.

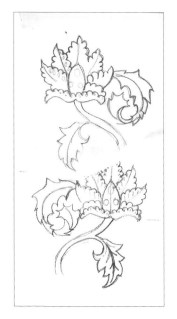

This flower motif, which was adapted from a wallpaper design by William Morris, was first traced the right way, then the tracing paper was reversed and the image redrawn. The tracing was transferred to watercolour paper and painted delicately with watercolour paint. This method is ideal for page borders.

Floral designs can be used to decorate letters. The stylised flower above was drawn within the curves of the letter C.

The design was sketched on layout paper using coloured pencils.

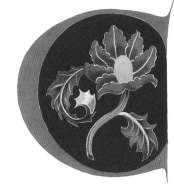

The finished design was transferred to watercolour paper and painted with gouache to provide a denser, richer colour contrast.

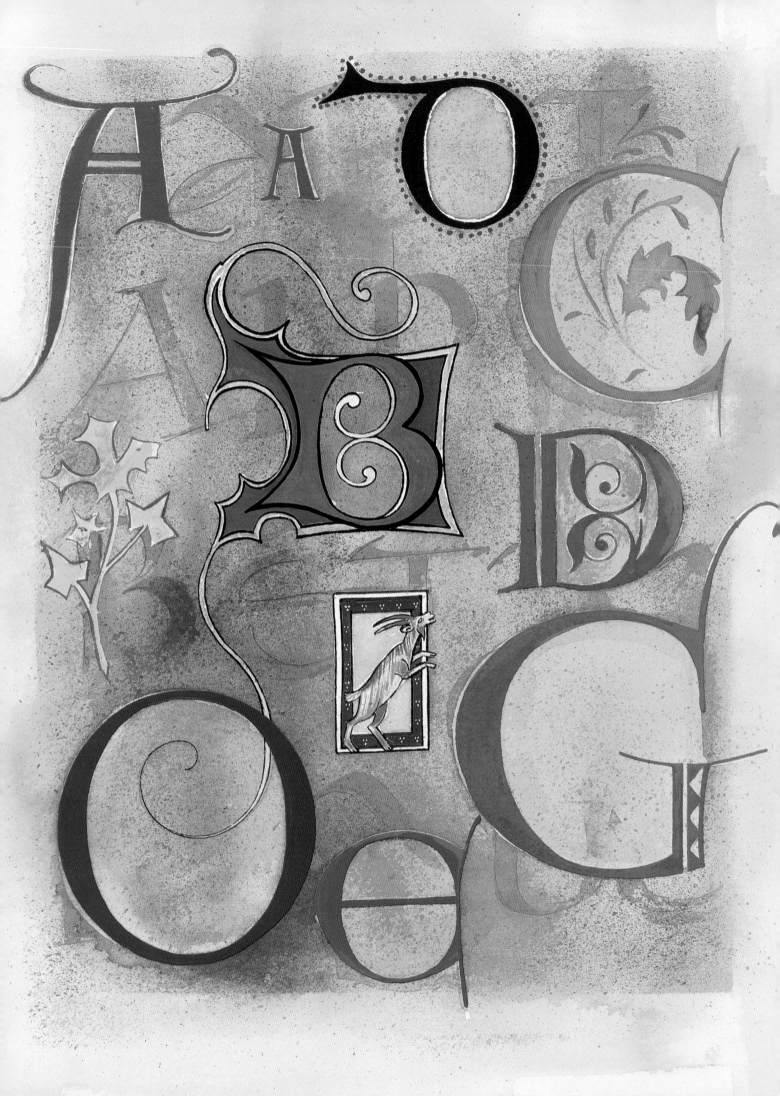

Letter forms

Versals

A Versal is a single capital letter, larger than the main text, which marked a break in the text. It was used as the opening letter of a paragraph or the beginning of a verse.

In many manuscripts the beginning of the text was written in Versals, creating a heading which emphasised the importance of the words, much as we now use large print. These are called display capitals (see page 10–11, the Bosworth Psalter).

The best examples of Versals were those written in the 9th and 10th centuries, which had simple and elegant pen-made forms. It was not long before the scribes gave these letters simple ornamentation or flourishes, first in the same colour (usually red), then in a contrasting colour.

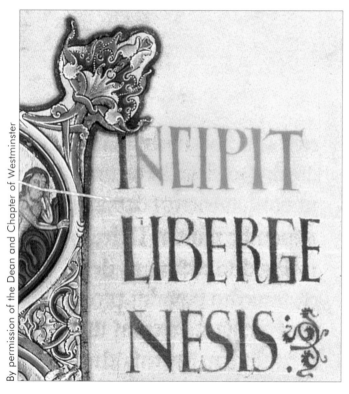

By permission of the Dean and Chapter of Westminster

The Winchester Bible
*Detail of Versals from the Book of Genesis, folio 5
(see also page 15)*

The Versals, right, are based on the proportions and elegant shapes of carved Roman Inscriptional Capitals. The grey letters are carefully-drawn and painted Roman Capitals based on the same letters. The red letters are Versals, quickly-drawn and filled with a pen. Note the difference the tools make to the structures.

Creating your first letters

Both historical and modern Versal forms are made with compound strokes of the pen. The thick strokes of the letter are made with three strokes of the pen; two outer strokes and a third which fills or floods the centre with ink or paint. The thin strokes are made with a single pen stroke, which when executed well gives the letter an elegant appearance. The letter structure follows closely the classical Roman capital, though the shape and form is influenced greatly by the use of the pen. The nib is held at zero degrees (horizontally) for the downward strokes and at ninety degrees to the line (vertically) for the cross strokes. This gives the widest-possible line for each letter stroke. For curves hold the nib at about twenty degrees. Follow the directional strokes of the arrows to create the letters below.

Note *The height of the Versal is eight stem widths (height = 8 x width of downward stem). If the stem is three strokes of the pen wide (3 x nib widths) the Versal will be 24 nib widths high.*

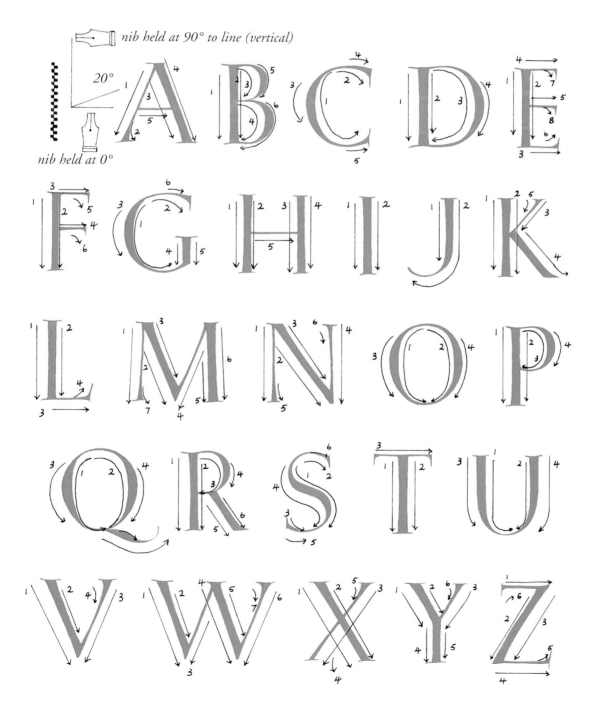

33

Basic straight Versal

It is important to retain the elegance of these pen-drawn capitals. The two outer strokes should curve inward slightly to the centre of the stem; this results in a subtle narrowing known as 'waisting' which makes the letter look more graceful. Use a dip pen with a No. 4 calligraphy nib (slightly less than 1mm) and black ink.

E

F

H

I

J

L

T

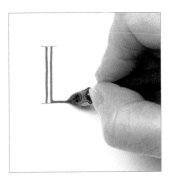

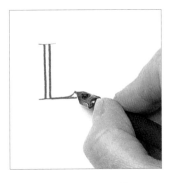

1. Holding the pen nib horizontally (at zero degrees), make the two downward strokes, 'waisting' them slightly. Add the top serif with the same horizontal angle.

2. Keeping the same pen angle add the bottom serif, then turn the pen nib to a vertical position (ninety degrees) and draw the line at the base of the letter.

3. With the pen still in a vertical position, add an inside line to thicken the bottom serif.

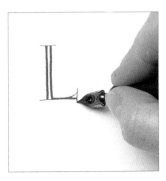

4. Finish the serif with a downward stroke.

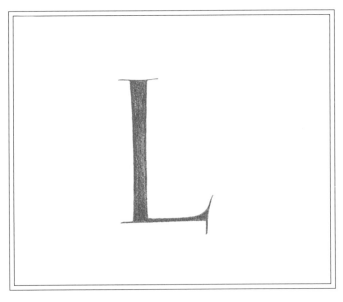

5. Flood the letter stem with ink using a third downward stroke, then fill in the serif.

Diagonal Versal

Hold the pen so it makes the widest possible line for all letter strokes – vertical, horizontal and diagonal. For serifs, hold the pen so it makes the narrowest possible line.

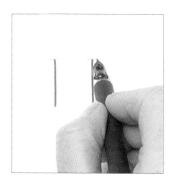

1. Holding the pen horizontally, make the downward strokes and top serifs on both outer stems of the N.

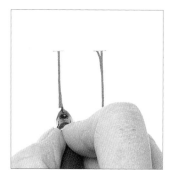

2. Add inside curves to the bottom and top serifs.

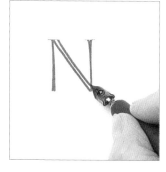

3. Add two diagonal lines from the top of the left-hand stem to the bottom of the right-hand stem using the thickest pen width, 'waisting' the diagonal stem slightly.

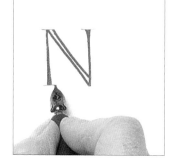

4. Holding the nib horizontally, add the top and bottom serif.

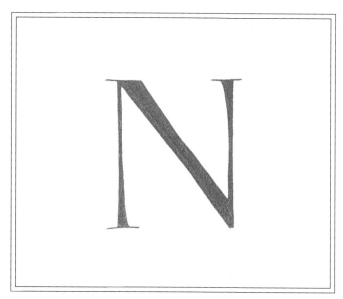

5. Carefully flood the diagonal with a third stroke and fill in the serifs.

Basic circular Versal

Hold the pen nib at a slight angle – about twenty degrees – to make the curves, to avoid thin strokes at the top and bottom of the shape. Make the oval inside shape first, and then add the weight on the outside to create the circular shape.

1. Holding the pen at a twenty-degree angle, draw the first half of the inside oval.

2. Keeping the same pen angle, draw the second half of the inside oval.

3. Add the two outer side strokes to complete the letter.

4. Carefully flood the side strokes with ink.

The completed letter

Combination Versal

The bowl of B, P and R relate to the letter O. Make the inside of the bowls oval and add the outside stroke to build the circular shape.

1. Holding the pen horizontally, make the first downward strokes, 'waisting' them slightly.

2. With the pen at a slight angle of twenty degrees, add the inside curves.

3. Add the bottom serif, then the outside curves.

4. With the third stroke, flood the downward stem and curves with ink.

The completed letter

Letter variations

These letter variations of Versals are a combination of the Uncial and the Roman Imperial capital. Uncial forms can be seen here in the letters d, e, m and u. In time, the decorative letter became more sophisticated and elaborate and their forms became *historiated* (incorporating an illustration of a scene related to the text); *zoomorphic* (containing animal forms) or *anthropomorphic* (containing human forms). For examples, see the illustrations from the Winchester Bible on pages 14–15. Different colours can give a simple contrast. Try varying the letter shapes, and do not make the letters too complex.

Note *The Versal in its simplest form was a pen-drawn letter, quickly filled with colour – usually red, but often blue and green.*

All examples on these two pages are taken from 10th-century English Versals. Simple decoration has been added to the letter stroke endings or within the letters.

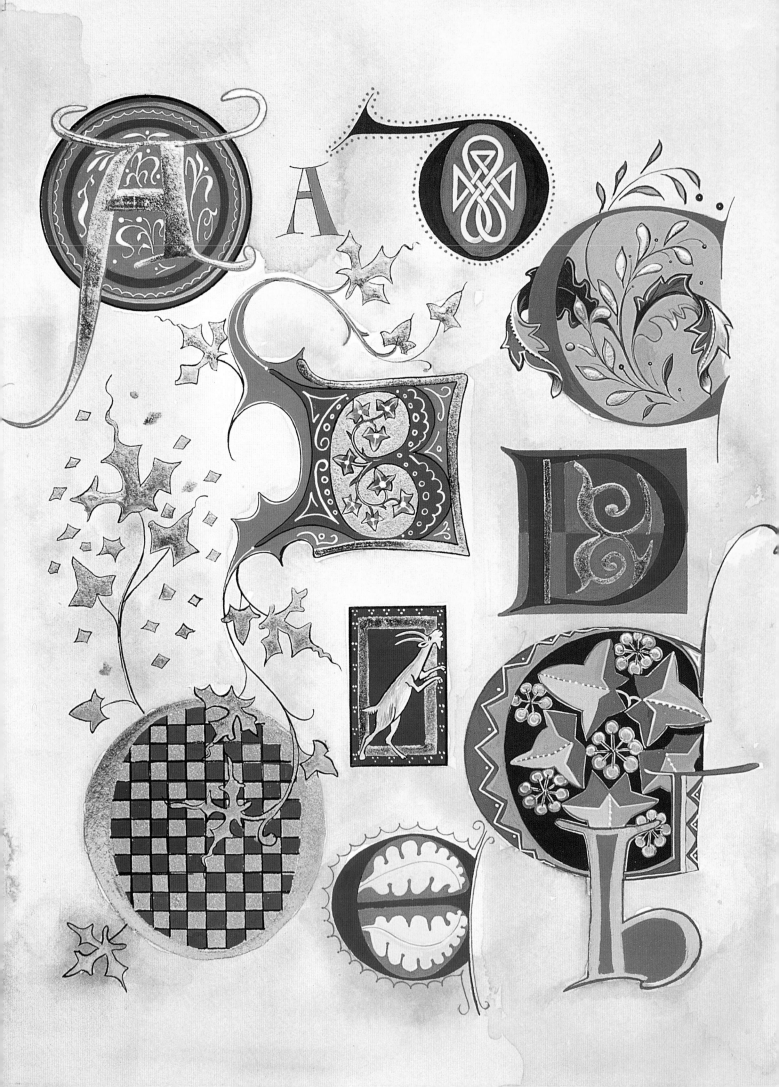

Adding Decoration

Using colour

Colour has a strong influence on our lives; its impact is instant as it is strongly linked to mood and feelings. Careful and thoughtful use of subtle colour can produce harmony, emphasise an idea or set a mood; bright colours create excitement, shout for attention and give a feeling of joy. The rich gold and bright colours used in manuscripts were a mark of religious esteem.

The pigments and dyes which produce paint colours are organic, mineral or synthetic in origin. Organic pigments have plant and animal origins. Ancient colours were made from plants like woad or indigo – which each produce blue – or animals: sepia is from the ink sac of the squid and kermes red from crushed beetles. Inorganic pigments are mineral in origin. Mineral pigments come either from the earth like ochre or sienna, or from semi-precious stones like lapis lazuli, which can be ground to produce the colour ultramarine. Many colours used in the past were corrosive or poisonous, and were often not permanent. Bright, permanent colours were expensive or laborious to make. The first synthetic colour was produced in Germany in the early 18th Century; now many pigments are artificially produced, including that which has replaced lapis lazuli.

Note When mixing colours always mix dark colours into light colours rather than the reverse, as dark colours will dominate light colours.

Bright colours
The brightest colours can be made by mixing the primary colours closest to each other on the wheel. Cadmium yellow and cadmium red make the brightest orange; cerulean blue and lemon yellow the brightest green and alizarin red and ultramarine blue the brightest violet. This is because each colour has a bias towards the other and contains a minimal amount of the third primary.

Subtle colours
Mixing primaries further away on the wheel produces duller, but often more subtle colours. If cadmium red (an orange red with a bias toward yellow) is mixed with cerulean blue (greenish blue with a bias towards yellow), the result is a dull violet with a tendency towards grey or brown.

Analogous colours
These colours are close to each other on the colour wheel, e.g. red, red-violet and violet. When they are used together they create harmony and mood.

Cadmium red (red-orange)

Alizarin red (red-blue)

secondary colour (orange)

secondary colour (violet)

Cadmium yellow (orange-yellow)

Ultramarine blue (blue-violet)

Lemon yellow (yellow-green)

Cerulean blue (blue-green)

secondary colour (green)

Primary, secondary and tertiary colours

The primary colours are red, yellow and blue, from which in theory all other colours can be derived. Mixing all three primaries produces grey or black. I use six primaries instead of the traditional three (two blues, two yellows and two reds) to produce infinitely more variation of colour. One of the best ways to familiarise yourself with colours is to make your own colour wheel – the one on the left is an example – and practise mixing.

Ultramarine contains a small amount of red, making it a reddish-blue, and **cerulean blue** has a small amount of yellow, which makes it a greenish-blue. **Lemon yellow** has a trace of blue, making greenish-yellow, and **cadmium yellow** has a small amount of red, making orange-yellow. **Cadmium red's** trace of yellow makes it orange-red, while **alizarin crimson's** trace of blue makes it bluish-red. Secondary colours are those produced by mixing two primaries together: orange (red and yellow); green (blue and yellow); violet (blue and red). Tertiary colours are those produced by mixing a primary colour, e.g. red with its adjacent secondary colour, e.g. orange.

Complementary colours

These are found opposite each other on the colour wheel. The complementary colour of blue is orange (made from red and yellow). In other words, the complementary of a primary colour is a mixture of the other two primaries.

When complementary colours are placed together, they produce 'vibration', which is why green on red is difficult to read. When used thoughtfully next to each other, however, they create a brilliance. Experiment to achieve some interesting results. When complementary colours are mixed, e.g. a small amount of violet into yellow, the result is a great range of subtle, semi-neutral colours.

The complementary colour of yellow is violet

The complementary colour of red is green

The complementary colour of blue is orange

Note *When mixing colours for painting, remember to mix enough to complete the work; matching a colour which has dried is almost impossible. Most watercolour or gouache can be kept for a few days if covered with a lid or clear plastic to prevent dust. Add a drop of water if necessary to return the paint to the right consistency.*

Additional colours
If you would like to add useful colours to your palette, cobalt blue is light-proof and may be mixed with other blues to create subtle changes in colour. Burnt sienna and raw umber are good mixing colours, especially with ultramarine blue. They can produce subtle greys, browns and virtual black. Oxide of chromium is a dull but subtle green. Viridian green and Winsor green are vibrant colours which mix well with others in the palette, but use sparingly. Zinc white is best for creating tints; permanent white is more opaque and is the best for highlighting.

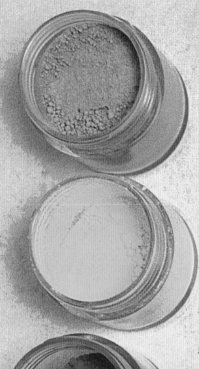

Paints and brushes

Medieval manuscripts derive their jewel-like quality from **egg tempera** – see recipe below. Made from dry ground pigment – the pure colour – with a binding agent of egg yolk or white (glair), egg tempera produces the flat but bright opaque colour which is so characteristic of decorative manuscript art.

 Gouache – the nearest modern equivalent – is also opaque, so different layers can be painted on top of each other. It is sold in tubes, and only a few colours will be needed to begin with: ultramarine blue, cerulean blue, lemon yellow, cadmium yellow, cadmium red and alizarin red. Later, you can add yellow ochre, permanent green, oxide of chromium, red ochre, burnt sienna, burnt umber, jet black, zinc white for mixing tints, and permanent white for highlighting.

 Watercolour is more suitable for the naturalistic painting of flowers and animals we prefer today. You will need ultramarine blue, cerulean or Winsor blue, lemon yellow and cadmium yellow, cadmium red and permanent rose, burnt sienna, burnt umber and lamp black. White is not necessary.

Brushes

At first you will need only four brushes: Nos. 000, 00, 0 and 1. Sable is best, but synthetic brushes are almost as good. You will also need a brush to dust away the gold and an old brush for binders and glues. Nylon or synthetic brushes are good for applying glues and sizes and for mixing.

Dry ground pigments

Pigment is the pure colour. Ready-made watercolour and gouache contain pigment, gum and other ingredients, but you can make your own paint from pure pigment. Store the pigment in airtight, labelled jars and handle carefully – some contain harmful substances.

Dry ground pigments

Making egg tempera

Break an egg and pour off the white. Take the yolk sac carefully between thumb and forefinger, hold over a clean container and pierce with a craft knife. Discard the empty sac.

Spoon a little dry pigment into a small china palette and grind with a glass rod or stopper. Add a little distilled water and mix thoroughly.

When you are ready to paint add a small amount of egg yolk. The mix should contain water and egg yolk in approximately the same proportions.

Pigment and water will last almost indefinitely in an airtight container, but once the egg has been added, the mix dries out very quickly, and cannot be re-used.

1 *Two water pots, one for rinsing the brush and one for clean water.*

2 *Eye dropper for adding small amounts of water.*

3 *Absorbent paper for wiping the brush.*

4 *China palette for mixing the paint.*

5 *Small brushes 000, 00, 0 and 1 for miniature painting.*

6 *Brushes for larger areas of paint: 2, 4 and 6.*

7 *Watercolour paints in pans or tubes for more naturalistic painting.*

8 *Gouache paint for bright, dense colour.*

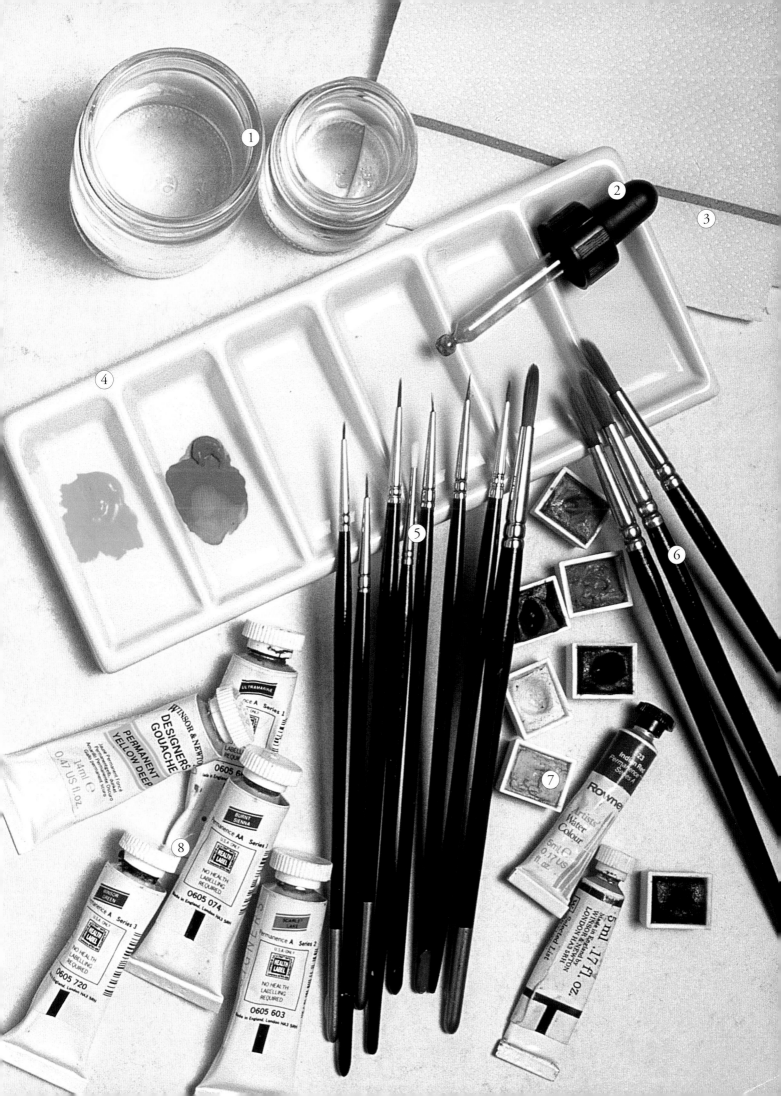

Monogram

The letters used for the monogram are simple Versals which have decorative extensions to the serifs on the letter R.

 The position of the letters within the monogram design can be determined very quickly by tracing each letter separately and moving the individual tracings around, one on top of the other, until the design succeeds. Additions can be made to the design in the same way. When the final traced design is ready to transfer to paper, it can be kept crisp and clean by making a separate carbon to slide under the image – a method which enables the tracing to be used many times. Images can be reversed easily if you avoid scribbling on the back.

YOU WILL NEED

180 gsm (90lb) HP paper
Tracing paper
2H pencil
HB pencil
Gouache paint: oxide of chromium; cadmium red; alizarin red

1. Use separate pieces of tracing paper to trace the letters so they can be tried in various positions. Try placing the letters one above the other or overlapping.

2. When you are happy with your design, tape the tracings into the final position.

3. Trace the decorative patterns and move them around over the taped-together letters in the same way.

4. When you are happy, tape them into position.

5. Place a clean piece of tracing paper over the taped and combined tracings and trace one final drawing.

6. At this stage, you may decide that the design needs more decoration. Trace the designs opposite for the extensions, and move them around under your tracing until they look correct. Add them to the drawing.

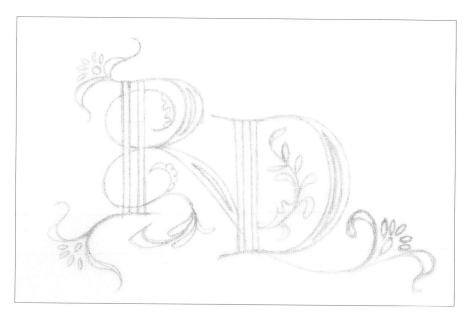

7. Add more patterns if desired to fill in any gaps.

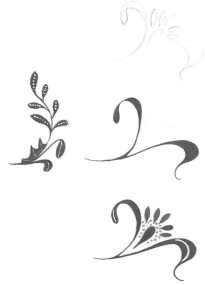

Making carbon paper for tracing

Using a carbon in this way keeps your tracing clean for future use

8. With an HB pencil, scribble horizontally and vertically on a separate piece of tracing paper, covering the whole area. Smooth over the pencil marks with another piece of tracing paper to remove excess graphite.

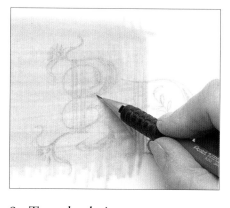

9. Tape the design to your paper, then slide the carbon paper you have created, pencilled side down, underneath. With a 2H pencil, start to transfer the design.

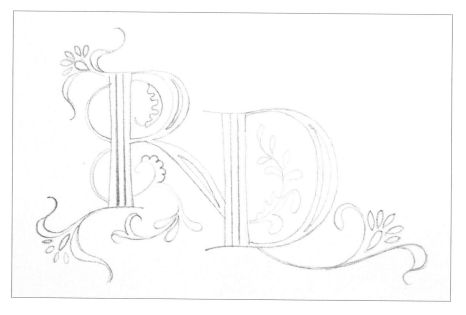

10. Remove the carbon paper and check that you have transferred the whole image. If not, fill in any gaps.

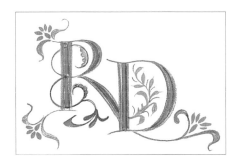 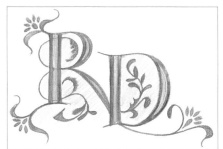 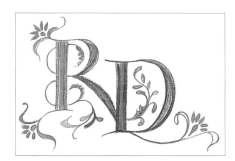

Always try out your colours first using coloured pencils or watercolours.
When you are happy, you can start adding colour to your design.

The finished monogram
Oxide of chromium was used to paint the letters, letter extensions
and leaves, and a mix of cadmium red and alizarin crimson to
paint the letter centres and the flowers.

Historical Celtic monogram

This monogram is based on two letters taken from the Lindisfarne Gospels, intertwined to make a decorative Celtic design. The subtle range of colours used in the gospels includes colour made with white and red lead; verdigris (green); yellow ochre; yellow arsenic sulphide (orpiment, which is highly poisonous); and kermes (a red colour obtained from insects). A range of pinks and purples came from folium (the flowers and fruits of the turnsole plant). The rich blue found in many manuscripts of that time came from Lapis Lazuli, and the minerals malachite and azurite (blue and green) were also used. Only a small amount of gold was used.

YOU WILL NEED

Tracing paper
Paper: good-quality cartridge or 180gsm (90lb) HP
2H Pencil
Permanent black ink
Pen: ¾ Brause ornament nib or brush
Gouache paint: oxide of chromium; Winsor green; permanent yellow; alizarin crimson; scarlet lake; zinc white
Paintbrush No. 00

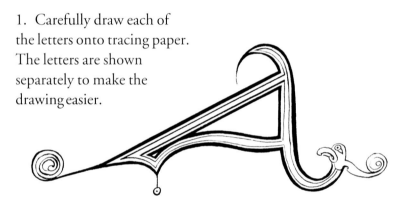

1. Carefully draw each of the letters onto tracing paper. The letters are shown separately to make the drawing easier.

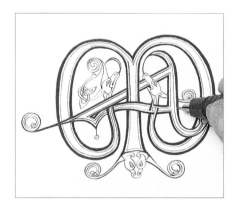

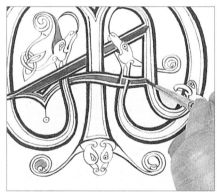

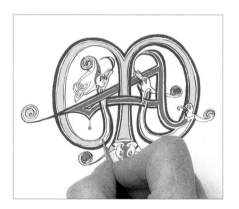

2. Tape the designs in the correct position and transfer to the paper using the carbon paper method shown on page 48. With a pen and permanent black ink, draw in the thin lines carefully, then add the thicker lines.

3. Using a No. 00 brush, paint in the green areas using a mix of oxide of chromium and permanent yellow deepened with a touch of Winsor green.

4. Paint in the yellow areas using permanent yellow.

5. Paint in the red areas using scarlet lake, alizarin crimson and a touch of zinc white.

6. Using a Brause pen or a fine brush, add one row of red dots all around the letters, then add a second row.

7. Infill the letters with red dots to complete the monogram.

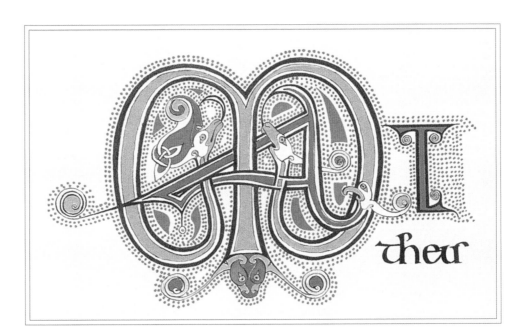

The finished design

The monogram features the first two letters of the word Mattheus at the beginning of St Matthew's Gospel (folio 186, the British Library), and is completed by adding the rest of the name with a calligraphy pen. The red dots provide a background of soft, glowing colour which helps to define the forms.

Acorn design

Any plant form can be used to decorate around a letter. For the decorated letter miniature project which follows, oak leaves and acorns interlace with the letter E.

One leaf and an acorn were drawn and traced, then a composite branch of leaves and acorns was made by using the tracing first one way, then reversed. The whole stem was painted: the top half in a naturalistic way with watercolour; the lower half with gouache, creating flat colour – useful for designing. After studying, drawing and painting the leaves, more stylised interpretations were created, including the curved design and border patterns.

Study of oak leaves and acorn painted in watercolour.

Stylised design of oak leaves using the study. Painted in gouache to give a flat finish.

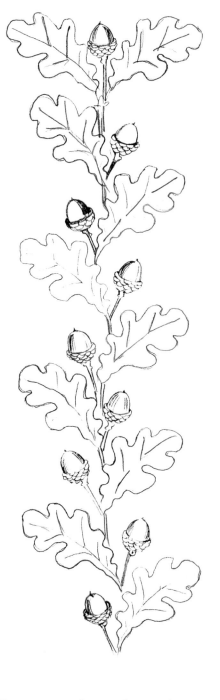

Pattern created using the traced design of a single leaf and acorn, then reversed.

Simple painted leaf and acorn.

Stylised interpretation to use in E design opposite.

Traced design.

Stylised design to make a border pattern.

Decorated letter

The inspiration for this design is the 15th-century Roman White Vine style of the Renaissance. Roman initials were interlaced with spiralling, intertwining vines which were usually without much colour and not part of the letter itself. The bright colours appeared in the backgrounds and on the initials. These were often decorated with the characteristic white or gold dots, in groups of three, enlivening the artistry.

YOU WILL NEED

Tracing paper
300gsm (140lb) paper
Pencils: 2H and HB
Acrylic red ink
Paintbrushes: Nos. 0 and 1
Gouache paint: scarlet lake; alizarin crimson; ultramarine blue; Winsor green; permanent yellow; zinc white; permanent white

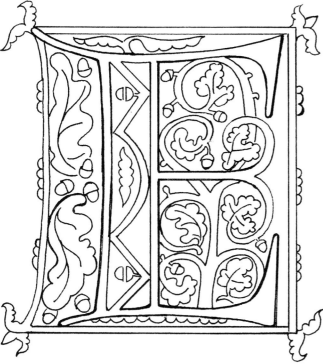

1. Trace the design from the pattern shown here and transfer to the paper.

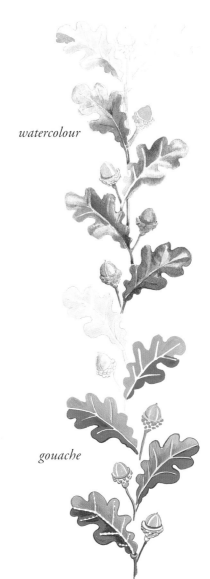

watercolour

2. Mask your work around the edges to keep it clean and smudge-free. Ink in the design using a pen and red acrylic ink.

The partly inked-in design

gouache

Oak leaf pattern painted using different media

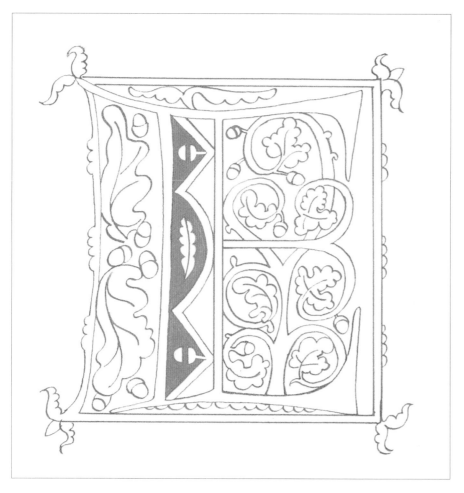

Note Build up colour by applying a thin coat of paint to see how the colours look. Second and third applications, in gouache, can be made as you build up your design.

Start by using a mid colour. Second and third colour applications can be the shadows (darker colours) and highlights (colours mixed with white). The final highlights are added in permanent white gouache to give the design form. Ink in the design using waterproof ink.

3. Mix scarlet lake and alizarin crimson and paint in the red areas.

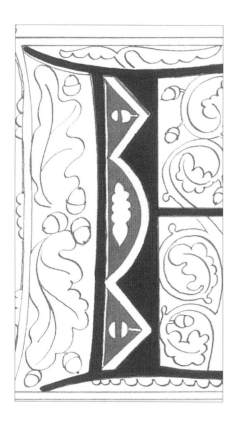

4. Paint in the blue areas with a mix of ultramarine blue and a touch of zinc white.

5. Add green made from a mix of permanent yellow, Winsor green and a touch of zinc white.

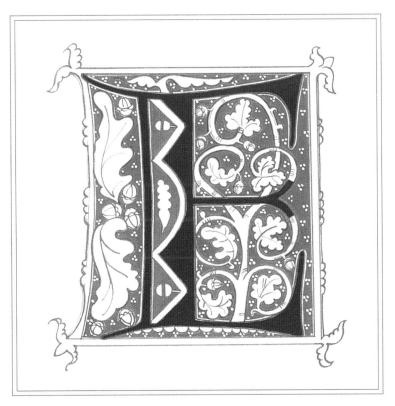

The finished painting
*The dots were added in groups of three using
permanent white gouache.*

Variations

These are modern ideas and interpretations, some adapted from historical models, for decorated initials. For more ideas, see pages 86–87.

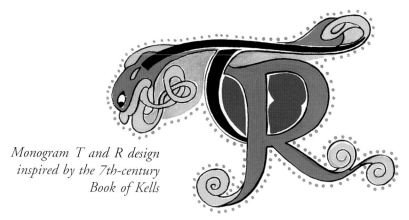

Monogram T and R design inspired by the 7th-century Book of Kells

Adapted from an early 16th-century French manuscript

Adapted from a late 10th-century Versal

A simple 7th-century Celtic knotwork design

Adapted from a late 10th-century manuscript

Ornate Versal with built-up Lombardic Capital based on an 11th-century design

Adapted from an early 16th-century initial

Letter adapted from those typical of the late 14th Century

Chequer and diaper patterns

The decorative possibilities are endless. These patterns used as backgrounds were popular in 14th-century manuscripts. Diapering usually means the figuring of a plain or patterned surface with a finer pattern, often in gold or white.

Modern adaptations

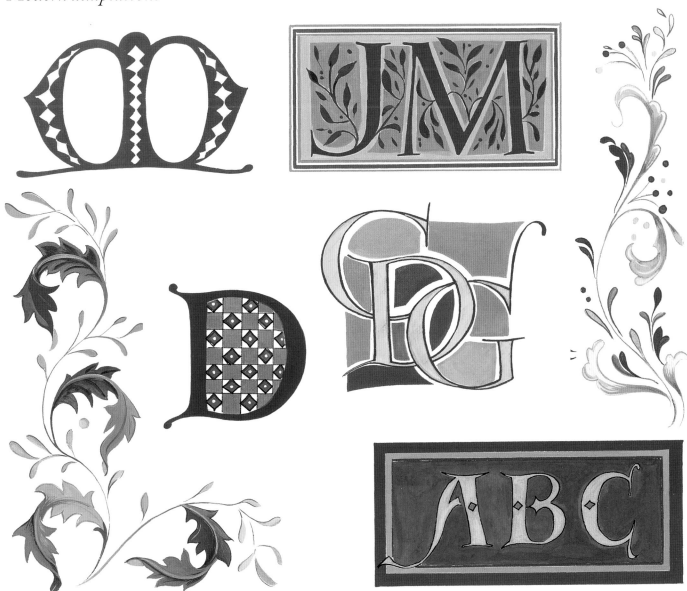

Using gold

Gold has unique qualities which make it a very special material to work with. It does not tarnish but retains its brilliance indefinitely; it can be beaten far thinner than other metals and it sticks to itself, which other metals will not do. Perhaps most importantly, every extra layer you add enhances its brilliance.

The usual way of working with gold is to complete any writing first, because that is where you are most likely to make mistakes. If you have gilded and painted before writing, it can be heartbreaking to have to begin again. So write first, then apply the gold, then paint. It is also wise to gild first because gold sticks to anything containing gum or glue; paint contains gum arabic so the gold will stick to it.

As gold sticks to itself it is easy to apply a thin layer first, then to follow with a thicker layer. A word of warning: handle the gold carefully – it not only sticks to itself but to everything else as well!

Gilding equipment

Most gilding materials are available only from specialist art suppliers. Some will sell smaller amounts of loose leaf and transfer gold, but this is not always cost-effective. A glass muller and sand-blasted glass slab are traditionally used to grind pigments or ingredients for gesso, but a pestle and mortar are a good substitute. When you become more serious about illumination, you may wish to add a gilder's tip for picking up the loose leaf gold; a gilder's cushion on which to lay loose leaf gold, and a gilder's knife with which to cut it.

Gold needs a size or glue to make it stick to paper or vellum. As these support materials are flexible, the gum used should also be flexible. Gum ammoniac and plaster-based gesso, the sizes used by professional illuminators, have been tried and tested for nearly two thousand years.

Note *Used sheets of transfer gold need not be wasted – they can be pressed onto painted surfaces when damp to add sparkle.*

1 *Loose leaf gold**

2 *Loose leaf silver*

3 *Transfer gold**

4 *Shell gold*

5 *Metallic gold watercolour*

6 *Metallic gold gouache*

7 *Metallic silver gouache*

8 *Copper metallic powder*

9 *Gold metallic powder*

10 *Used transfer gold*

** In the US, loose leaf gold is known as transfer gold and transfer gold as patent gold.*

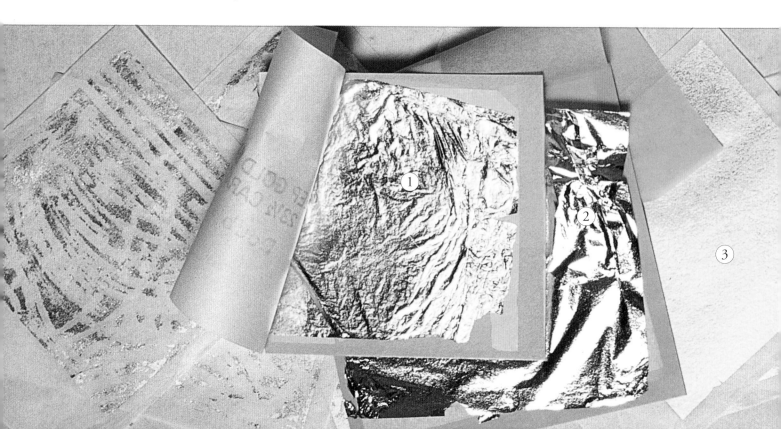

Materials

Gold leaf This is available in books of 25 leaves, which may be unattached (loose leaf gold), or attached to a backing sheet (transfer gold). The gold should be at least 23¼ carat. There are two thicknesses: single or double (extra thick gold). Beginners should start with single transfer gold, followed by double gold; as gold sticks to itself it is easier to apply a thin layer followed by a thicker layer. Keep the books safe between two pieces of stiff card when not in use.

Other precious metals can be used. **Silver** is also available in books of 25 leaves, but unless coated, it will tarnish with exposure to the atmosphere, taking on a bluish tinge and eventually turning black. It is also difficult to apply because it must be laid in a single layer. **Platinum, palladium** or **aluminium** can be used instead, but the first two are expensive and aluminium is difficult to handle and dull in colour.

The gilder's tip, cushion and knife are very expensive and are not essential. The glass muller and slab are used for grinding.

Shell gold This is real gold powder mixed with gum Arabic. Originally kept in a shell, it now comes in a small pan. It can be used to paint flat areas of gold, such as backgrounds, or for filigree designs.

Metal leaves such as **Dutch Metal** or **schlag** are much cheaper, and are fun to use. They cannot be burnished, but stay shiny. They are, however, difficult to apply and seem to stick only to acrylic mediums and PVA. They are available in gold, silver and copper colours plus other metallic finishes.

Gold and silver powders These metallic powders are available with an adhesive (dextrin, a starch derivative) already added. If it does not contain adhesive, you will need to add water and liquid gum arabic before you start painting.

Gold and silver gouache is metallic powder mixed with gum. It comes in tubes, is easy to use with a brush or pen, but has limited shine.

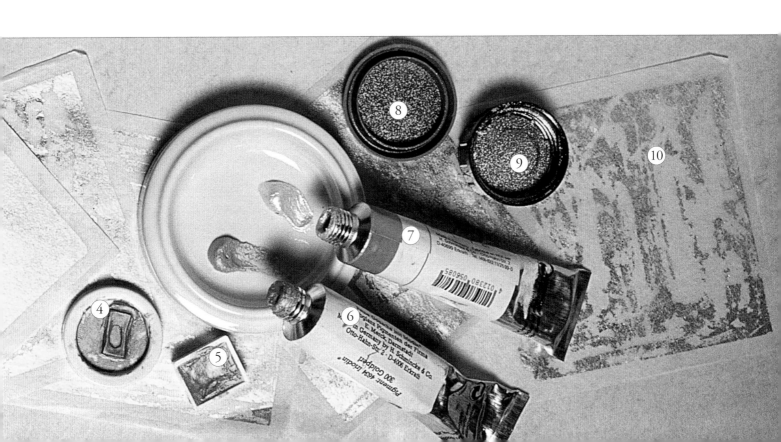

Other items

1 **Pestle and mortar** to grind materials for gesso or pigments for paint
DO NOT USE THESE FOR OTHER PURPOSES AS SOME SUBSTANCES ARE TOXIC

2 **Armenian bole** to add pink colour to gesso

3 **Seccotine** (fish glue)

4 **Gesso cakes** made in advance and kept in airtight container

5 **Distilled water** and **eye dropper** for adding water to ingredients

6 **Slaked Plaster of Paris** for gesso

7 **Oil of cloves** and **pin** add one pinhead to gesso to prevent bubbles

8 **Brown sugar** for gesso

9 **White lead carbonate** an ingredient of gesso. Handle with care and do not expose as shown in photograph – *it is extremely poisonous*

10 **Measuring spoons** for accurate measurement of gesso ingredients

11 **Sand-blasted glass slab** for grinding ingredients – can be used as an alternative to pestle and mortar

12 **A craft knife** with rounded blade or scalpel with curved blades (Nos. 11 and 15) for trimming away gesso and unwanted gold

13 **Old brush** to be used only for brushing away pounce

14 **Dip pen** with fine nib for drawing fine painted lines

15 **Nylon brushes** for applying gums, ammoniac size or gesso

16 **Gum ammoniac** in lumps – see recipe overleaf

17 **Smooth agate stone** for polishing the gesso

18 **Silk square** for polishing the gold

19 **Large brush** for dusting away the gold

20 **Scissors** for loose-leaf and transfer gold (do not use for anything else)

21 **Agate burnishers** medium dog-tooth (size 24) and small dog-tooth (size 34)

22 **Agate pencil-point burnisher** for polishing into tiny crevices and impressing point patterns into gold (optional)

23 **Psilomelanite burnishers**

Not shown

Glassine or crystal parchment paper to protect your work when burnishing gold (see page 20)

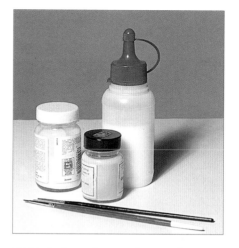

PVA (polyvinyl acetate) a modern size or glue for gilding (in bottle); acrylic gloss medium, a modern glue for gilding on paper or wood (in jars); brushes.

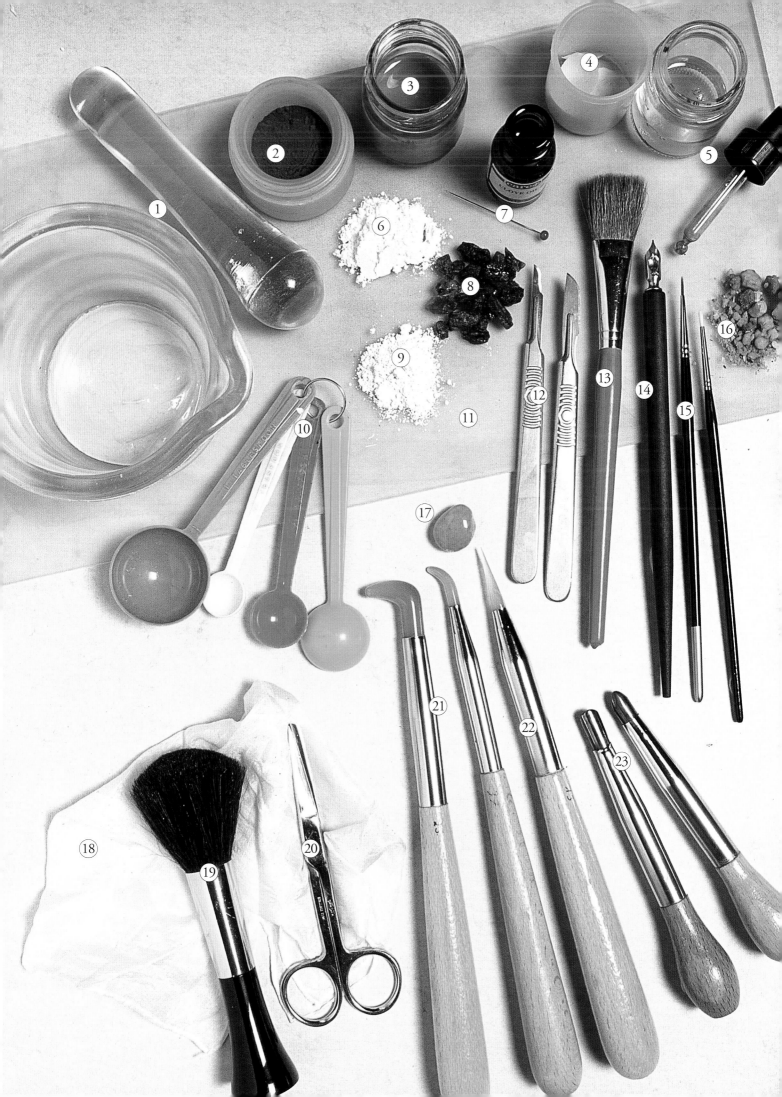

Applying gold using gum ammoniac

Gold needs a size or glue to make it stick to paper or vellum. These are flexible, so the gum must also be flexible. Professional illuminators have used both gum ammoniac and plaster-based gesso for nearly two thousand years. Make a small amount to begin with as it will not keep indefinitely.

Gum ammoniac size is made from the milky secretions of an African plant and is extremely sticky. It flows easily from a pen, so you can write with it, then lay gold leaf on top to create real gold writing. It can also be used on large areas of paper or vellum for gold backgrounds. Ammoniac size gives a better result than shell gold, though not as good as gold laid on a gesso ground. It can be burnished only if great care is taken (see note on page 65), but it can be polished with a piece of silk.

The size comes in lumps which look like muesli, and is simple to prepare – see below. It is also available ready-made in liquid form. It is transparent when dry, but a touch of cadmium red watercolour will tint it light pink so you can see it as you work. Traditionally, the size was coloured and preserved by adding a few strands of saffron.

YOU WILL NEED

Pestle and mortar
Gum ammoniac in lumps
Distilled water
Two small glass jars or pots with lids
Piece of stocking or fine mesh to strain glue
Red watercolour to tint the size pink

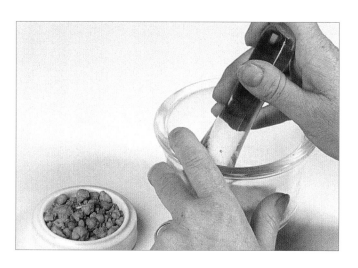

1. Put the gum ammoniac into a mortar, removing any seeds, stones or husks, and grind it into fine granules. The pestle and mortar should only be used to grind gum ammoniac – do not use for preparing food.

2. Transfer the granules into a small container.

3. Barely cover the granules with distilled water. Leave overnight or for at least 12 hours, stirring occasionally, until it has the consistency of single cream.

4. Strain through a fine mesh into another small jar, taking care not to push any bits through the mesh. Throw away the mesh. The liquid in the second jar is the size.

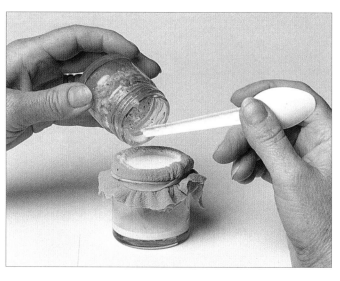

Horse

This miniature of a prancing horse was copied from the Ashmole Bestiary, a manuscript made in England – probably in the north Midlands – in about 1210 and now kept in the Bodleian Library, Oxford. Medieval bestiaries contained descriptions and miniatures of birds and animals.

For this project, traditional ammoniac size and transfer gold are used. This produces a beautifully flat, gilded background which is ideal for larger expanses of gold. The finished miniature can be framed.

YOU WILL NEED

HP paper 300gsm (140lb)
HB Pencil
Tracing paper
Permanent black ink
Old paintbrush or quill pen
Sheet of glass or laminated material
Paper tube
Transfer gold
Large soft brush
Silk square or dog-tooth burnisher
Paintbrushes: Nos. 1 and 2
Watercolour paint: yellow ochre;
* permanent yellow; burnt sienna*
Gouache paint: ultramarine blue;
* Winsor blue; zinc white;*
* cadmium red; scarlet lake;*
* permanent green; lemon yellow;*
* black; burnt sienna;*
* permanent white*

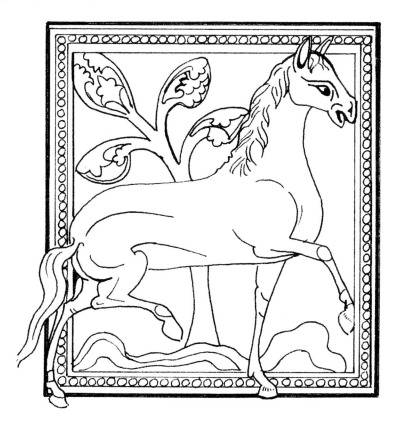

The source of the original miniature is MS Ashmole 1511, folio 32v reproduced by permission of the Bodleian Library, the University of Oxford.

1. Trace the design on to paper (see page 47). Ink in the main outlines with permanent ink, leaving inside areas as pencil lines.

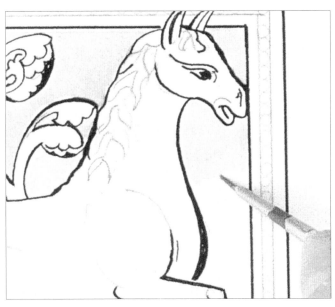

2. When the size is ready, use an old brush to apply it thinly and smoothly to the areas you wish to gild. Rinse the brush in warm water as soon as you have finished.

Note *After applying the size, mask the rest of the design with paper to keep it clean while you are working.*

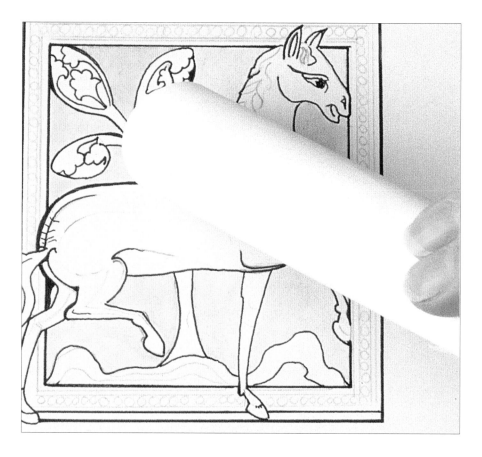

3. Make sure all your tools and materials are to hand. Place the design on a cold surface – glass is ideal. Make a small paper tube and, taking a deep breath first, exhale twice on to the area you will be gilding. The warm breath, aided by the cold surface behind, will moisten the size and make it sticky.

4. When you have dampened the glue, work quickly. Lay the transfer gold face down and press fairly firmly with your finger. If the gold does not stick, breathe through the tube on the size to moisten it again.

5. Pull back the transfer and you will see the gold deposited on the glue which was your design. Repeat steps 3–5 until the whole area is covered with gold.

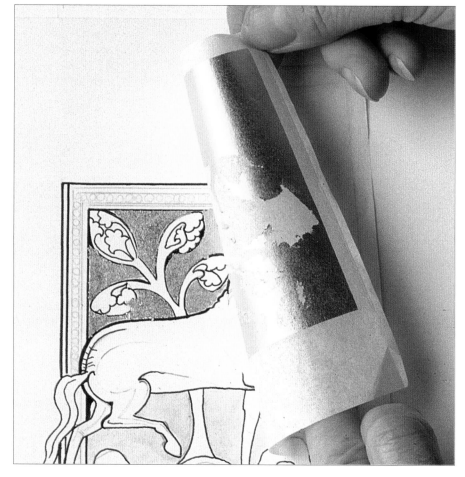

6. Leave the design until it is completely dry – at least thirty minutes – and brush away any loose gold with a large, soft brush.

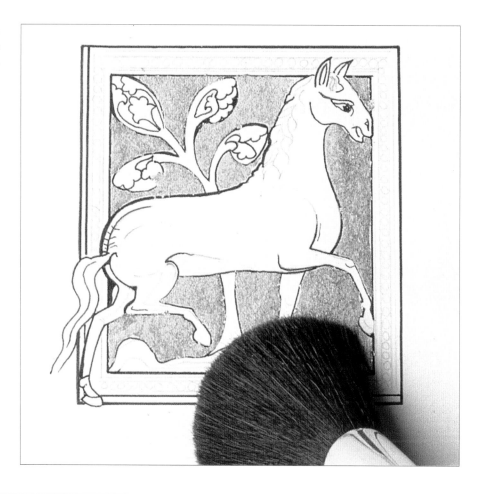

7. Polish the gold areas with a silk square, or burnish gently with a dog-tooth burnisher. The design is now ready to paint.

Note If using a burnisher take care not to burnish too much or too hard. Friction from the burnisher creates heat which makes the ammoniac size very sticky and can damage the surface. If you feel any drag on the burnisher, stop immediately.

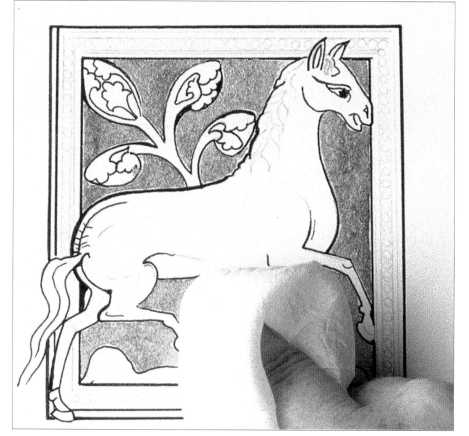

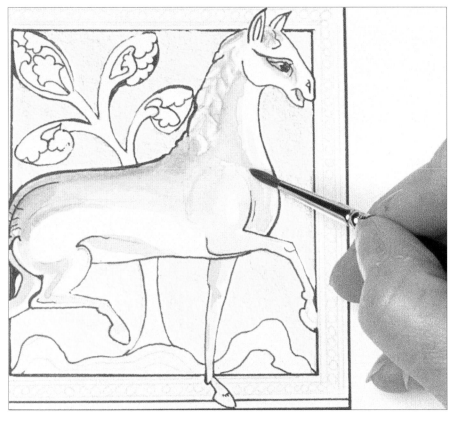

Note When working, keep the paint fairly dry so it does not 'blob'. Always mix enough main 'stock' colours to complete your design. Take small amounts of the main colour to mix tints and shades.

Adding zinc white to your main colours will produce pastel shades or tints. For shading, mix the main colour with darker colours.

8. Using watercolours, paint in the horse with a No. 2 brush, yellow ochre, permanent yellow and burnt sienna. Gouache should be used for the rest of the painting.

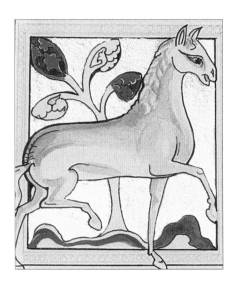

9. With gouache and a No. 0 brush, paint the blue leaves and ground beneath the horse with a mix of ultramarine, Winsor blue and a touch of zinc white for lighter tones and black or burnt sienna for the shading of greys or blues.

10. Paint the red leaves and borders with a mix of cadmium red and scarlet lake, adding zinc white for lighter areas.

11. Mix permanent green and lemon yellow with a small amount of zinc white to soften the colour, and paint the green stem.

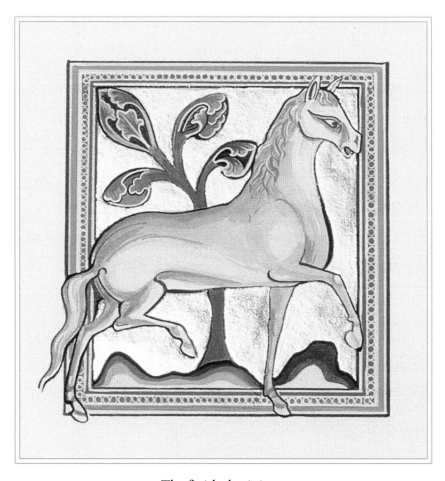

The finished miniature
*The outlines have been re-established with black gouache
and permanent white highlights have been added to the
leaves and borders of the frame to complete the design.*

Cat

Simple raised gilding using a modern glue or size, PVA (polyvinyl acetate) is used for this project. PVA is easily available, and raised gold with a beautiful shine can be achieved with practice.

PVA size can be applied in two ways; either by building up several layers of glue, allowing 30 minutes' drying time between each application, or by applying one thick coat only. For the first method, mix half PVA glue and half distilled water. For the second, less water is required and the PVA is applied like thick cream.

A modern cat design has been chosen to accompany the gilded letter. The preliminary sketches were inspired by studying a book on cats to find suitable poses. A selection of rough drawings is reproduced below.

The chosen cat was traced and – using the method given on page 46 – moved around with a separate tracing of the letter C until a pleasing design was achieved. Skilful painting gives the cat a 3-D image, as though it is walking through the letter.

YOU WILL NEED

Paper: HP 300gsm (140lb)

Tracing paper

Pencils: 2H and HB

Dip pen and black Indian ink

PVA (polyvinyl acetate) glue

Paintbrushes: Nos. 0, 00, 000 and 2

Watercolour paint: cadmium red; burnt sienna; ultramarine blue

Gouache paint: gold; scarlet red; alizarin crimson; ultramarine blue; burnt sienna; yellow ochre; permanent white

Transfer gold: half sheet

Large, soft brush

Silk square

Dog-tooth burnisher

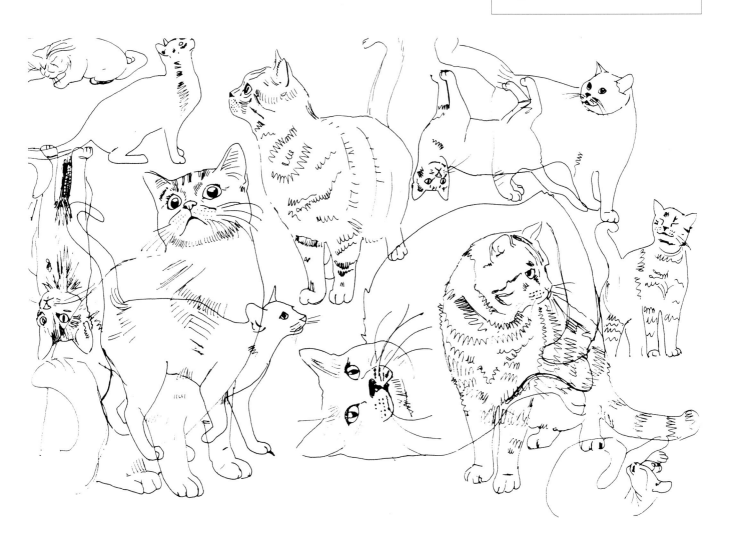

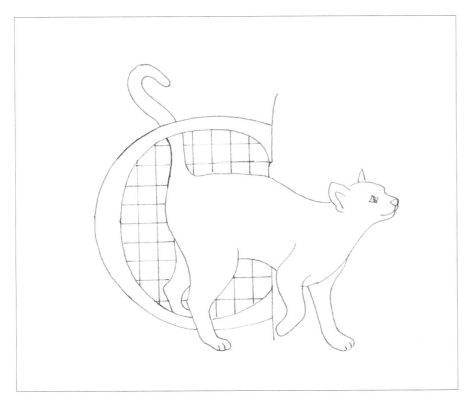

1. Trace the design on to good-quality HP paper 300gsm (140lb).

> **Note** *A chequer pattern is used in the background of the letter C. This is a repetitive geometric pattern, which becomes a diaper pattern when gold or white filigree is painted in the squares. These patterns are seen from the 11th Century onwards.*

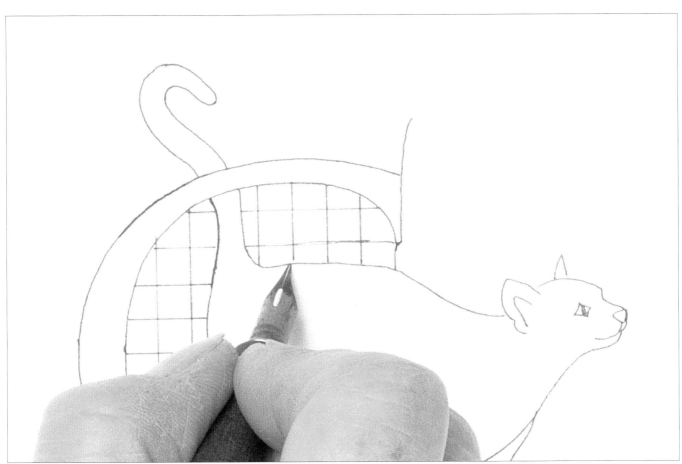

2. Using a dip pen with a small nib and black Indian ink, outline the design. Areas which are not being worked should be masked to avoid marking them.

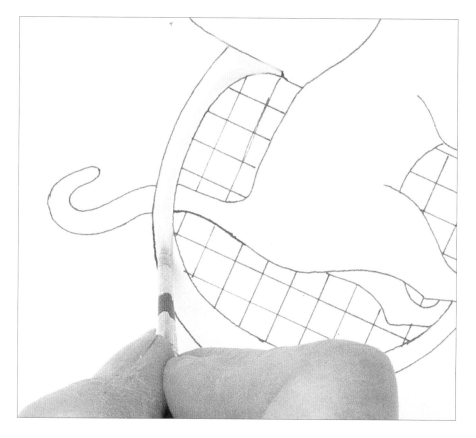

3. Start to fill in the letter C using PVA glue and a No. 0 paintbrush or a quill. PVA glue is transparent when it dries, so it is a good idea to tint it pink. Lay down a blob of glue, then pull it along in a smooth line. Start at one end of the letter and move quickly to the end.

Note To apply PVA, load the brush with a small amount of glue and pull it along, rather than painting which will cause streaking and grooving. Do not touch any areas which have begun to dry, as this will leave a mark. You will need to rinse the brush periodically, as it will become overloaded with glue.

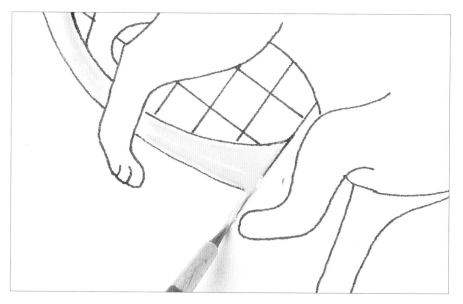

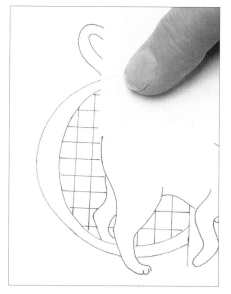

4. Place a blob of glue at each end of the 'C', then tease out the serifs at the top and bottom. Leave it to dry for thirty minutes. When it is dry, the glue will appear matt rather than shiny.

5. Make a small paper tube and, taking a deep breath first, exhale twice on to the area you will be gilding (see steps 3–5 on page 64) to warm and moisten it. Working quickly as the effect will not last long, lay the transfer gold face down over the glue. Press the gold down gently with your finger.

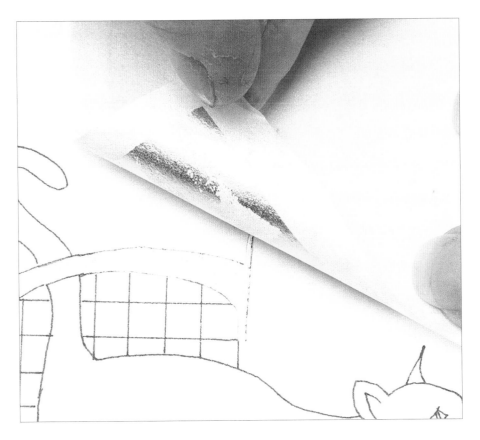

6. Lift the transfer gold sheet to make sure the gold has been deposited on the letter.

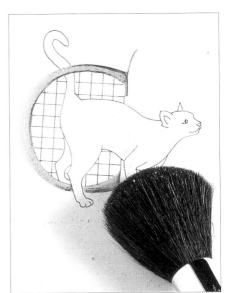

7. Repeat the process and finish gilding the letter C. Brush away any excess flakes of gold with a large, soft brush.

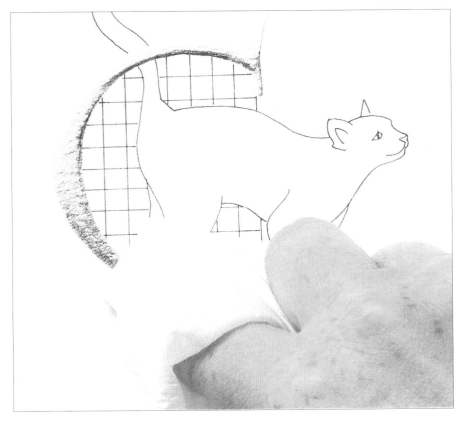

8. Polish the gold with a silk square. Rub gently at first, as PVA is often soft beneath gilded areas at this stage. Burnish with a dog-tooth burnisher when fully dry (at least 12 hours).

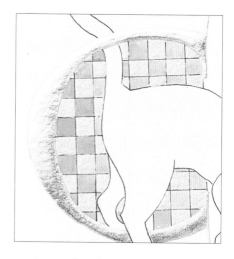

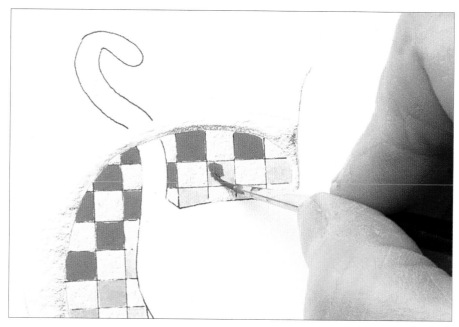

9. Paint the chequer pattern using a No. 00 brush and watercolour (or thin gouache) in cadmium red, and gold gouache. It is often easier to establish your colours by painting in watercolour first, so that any changes are easy to make.

10. Using a mix of scarlet red and alizarin crimson gouache, paint over the red squares with a No. 00 brush. Give the gold gouache a second coat to make it more shiny.

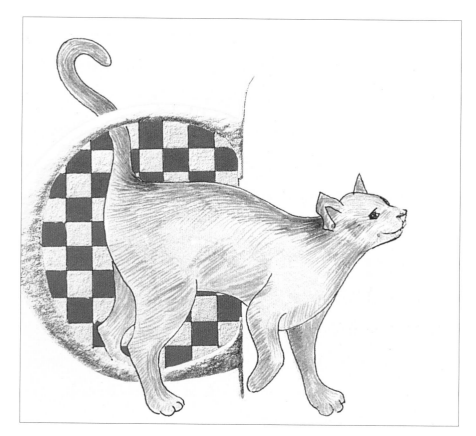

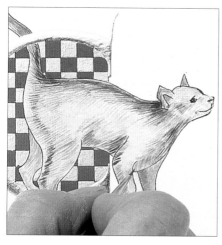

12. Build up the hair with short strokes to create separate hairs, using ultramarine blue, burnt sienna, or a mix of the two paints. Yellow ochre and permanent white are used as highlights. Many layers of colour can be built up using this method.

11. To paint the cat, use a No. 2 brush and establish the colours by laying in a watercolour wash of burnt sienna and ultramarine blue. When dry, start to paint in the fur using a No. 000 brush, ultramarine blue and burnt sienna gouache.

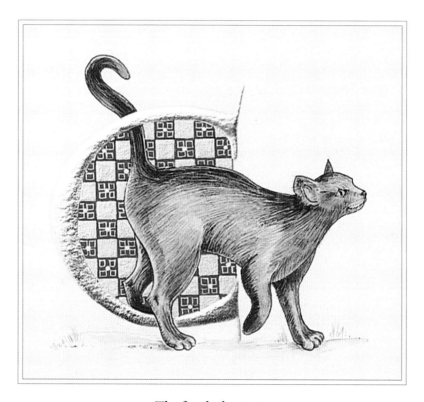

The finished painting

The white dot in the cat's eye, the whiskers and the design on the diaper pattern were added after all the layers had been completed, using permanent white gouache. The diaper patterns on the chequered design were painted in white gouache to add interest.

Winchester Bible

The Winchester Bible is the finest of the 12th-century illuminated bibles. Its large size, quality of illustration and lavish decoration make it one of the great masterpieces of Romanesque illumination. Most of the illuminated initial letters in the Winchester Bible are historiated (see page 14).

This project is taken from the historiated initial V in the Book of Jeremiah, in which Jeremiah receives his prophecy from God. In this project, which uses PVA as the size for raised gold, you will be learning the techniques of creating form and colour in the intricate painting.

YOU WILL NEED

HP paper 300gsm (140lb)
Transfer gold
PVA glue
Synthetic brush No. 00
Technical pen
Permanent black ink
Clear tape
Large soft brush
Glassine paper
Agate burnisher
Silk square (optional)
Watercolour paint (optional)
Gouache paint: ultramarine blue; Winsor blue; zinc white; permanent white; lemon yellow; permanent yellow; yellow ochre; burnt sienna; Winsor green; permanent green; cadmium red; alizarin red
Brushes: Nos. 1, 0, 00, 000 and 0000

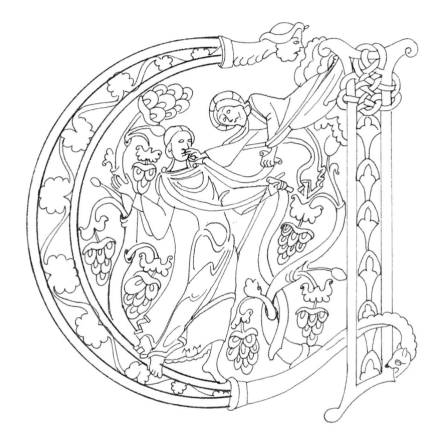

The historiated initial V from the Book of Jeremiah, by permission of the Dean and Chapter of Winchester

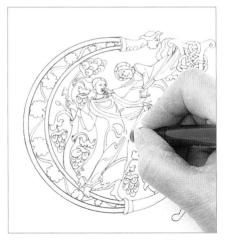

1. Trace the design on to HP 300gsm (140lb) paper. Outline the whole design using permanent black ink in a technical pen.

2. Mask surrounding areas to keep the work clean. Paint on PVA size with a No. 00 synthetic brush on the areas where the gold will be (see cat project, page 70). Rinse brush in cold water when finished.

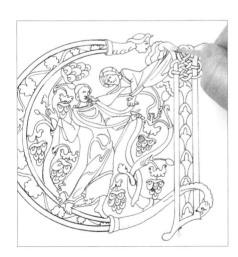

74

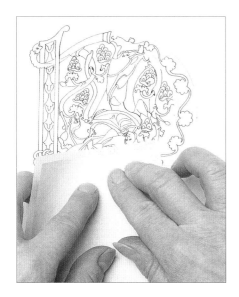

3. Tape your work to a cold glass surface. Make a paper tube and exhale through it on to your work to prepare areas for gilding (see page 64). Lay the transfer gold face down on the design, pressing firmly with your finger.

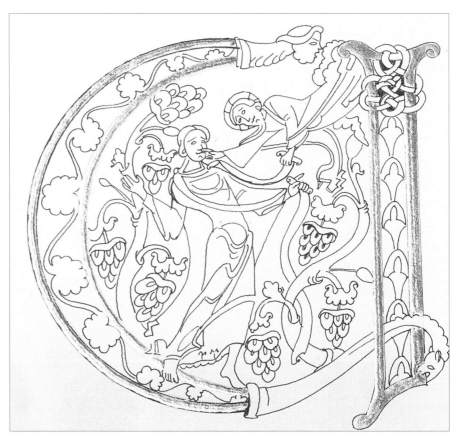

4. Repeat until the entire letter is covered with gold. Brush away any excess gold using a large, soft brush. Lay glassine paper on top of work, and burnish gently or polish with a silk square.

Note When using a burnisher, take care not to burnish too much or too hard. Friction from the burnisher creates heat which makes the size sticky and can result in damage to the surface. If you feel any drag on the burnisher, stop immediately.

5. Leave your work until it is completely dry – preferably 12 hours – then burnish directly on to the gold. Start gently, and build up to applying firm pressure.

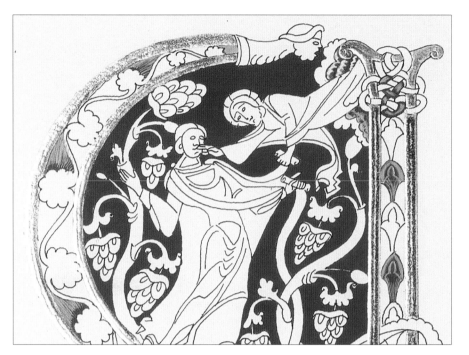

7. Paint in the highlights of the small motifs carefully using mid-blue with a little more zinc white added. Paint the shadows by adding more ultramarine to your mid-blue mix.

6. Mask the surrounding areas and, using a No. 1 brush, begin to paint your design with a mid-blue mixed from ultramarine and Winsor blue gouache with a little zinc white. Make sure that you mix enough paint for all the areas of blue, allowing extra for the highlights and shading.

8. Paint the yellow areas using mid-yellow made from permanent yellow and lemon yellow. Mix enough mid-yellow to allow you to create a lighter tone (add zinc white) and darker shadows (add yellow ochre or burnt sienna). Add a touch of alizarin red to the mid-yellow to make orange, then paint some of the yellow areas.

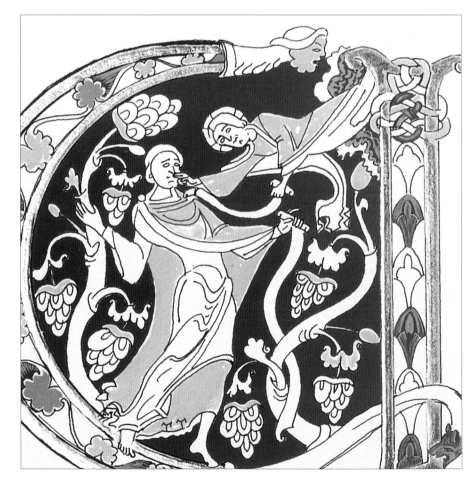

9. Add the other flat colours to the design: green (made with Winsor green and permanent green), more orange and violet. Mix a large enough quantity of each mid-colour to cover the relevant area and leave enough over to develop the shades and the tints.

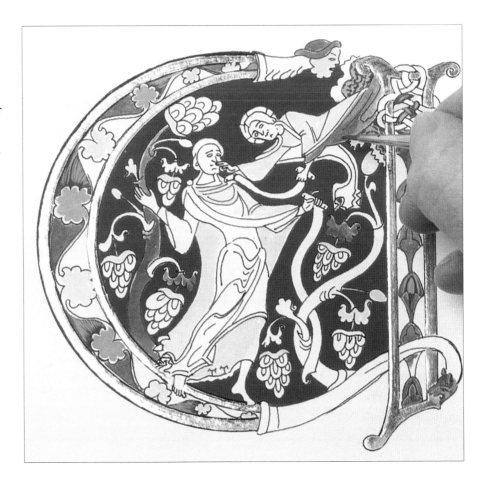

10. Once you have painted all the flat mid-colours of the design you can begin to create darker and lighter tones for patterning. Use a 00 and 000 brush. Build up the colour using small strokes.

Note *The designs are decorated with a range of tones and highlights, so when applying a flat main colour, add a touch of zinc white to create lighter tints or dark colours for shading.*

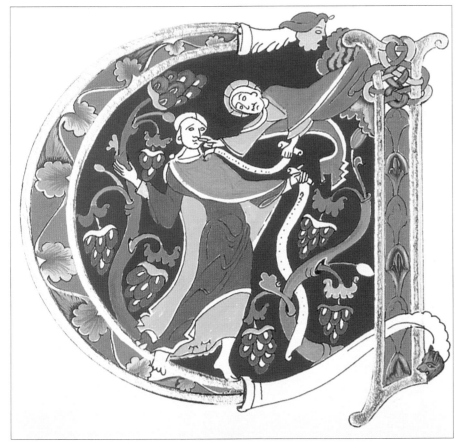

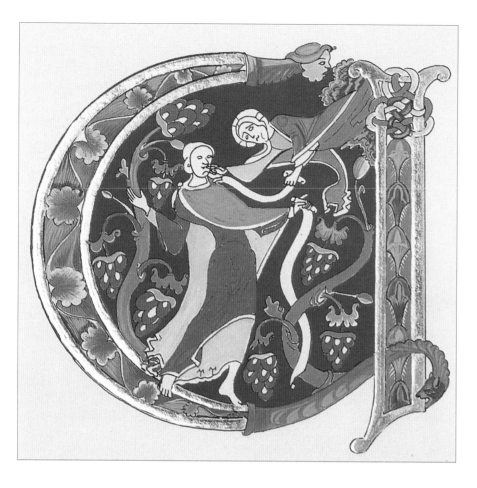

11. Paint in all the red areas using a mix of cadmium red and alizarin red. Mix pastel tints by adding zinc white to the red mix. Create darker shades by adding more alizarin red to the mix. Use small brush strokes with a small brush (No. 000 or 0000) to build up the colour and liveliness of the design.

Note *Be prepared to take your time when painting this miniature, especially when you are working on the more intricate areas.*

12. Add the final white highlights to the design using permanent white and a No. 0000 brush.

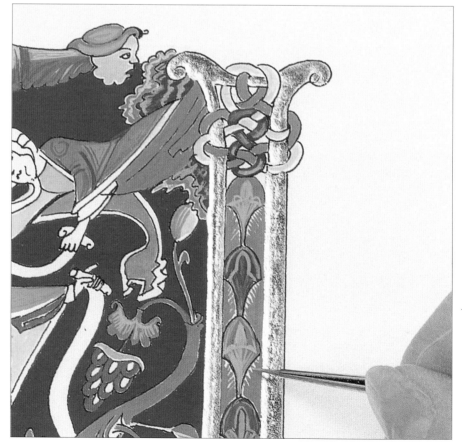

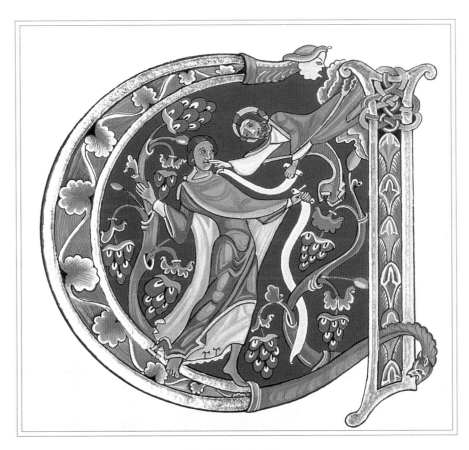

The finished design
The historiated initial V from the Book of Jeremiah.

Using gesso

Gesso can be used on both vellum and paper, and provides an ideal sticky base for applying transfer gold. The gesso can be 'revived' simply with warm breath, and each additional layer of transfer gold applied will improve the finish. The next project uses vellum (skin) and both transfer and loose leaf gold, which will make the gold very bright.

Making Gesso

Place the dry ingredients in a pestle and mortar and grind well. Add the seccotine and distilled water, and continue grinding until it is smooth and creamy. Spoon the mixture into 25mm (1in) cakes on polythene film. When the cakes are dry, store them in a plastic container.

*Making slaked plaster

You can buy slaked plaster – used in the gesso recipe above – but it is easy to make. A batch will last for years stored in an airtight plastic container.

Method: put the water in the bucket and sprinkle on the plaster, stirring continually with a wooden spoon to prevent it from setting. Continue to stir for an hour to prevent the plaster hardening. Leave for 24 hours. Drain off the water, add fresh water and stir for 10 minutes. Leave for 24 hours. Repeat the last procedure each day for a week, then every other day for three weeks. Drain through a fine muslin cloth and spread the slaked plaster on to polythene or into a large plastic container to dry. When almost dry it can be scored to make it easier to break off small amounts. It can be ground into powder before use.

GESSO INGREDIENTS

Pestle and mortar
*8 parts slaked plaster**
*3 parts powdered lead
 carbonate (POISONOUS)*
1 part ground brown lump sugar
pinch of Armenian bole
1 part seccotine (fish glue)
Distilled water to mix
Polythene film

(use measuring spoon for all ingredients)

SLAKED PLASTER INGREDIENTS

*25gm (8oz) fine dental plaster
 of Paris*
*3.5 litres (one gallon) of water
 (preferably distilled)*
Wooden spoon
Plastic bucket
Muslin cloth
*Polythene film or large plastic
 container*

Reconstituting gesso for use

YOU WILL NEED

Gesso
Two tiny glass jars
Distilled water and dropper
Glass rod

Note *Push the gesso gently with a glass rod while it softens to help it absorb the water. Do not stir – this creates bubbles which are difficult to disperse. If bubbles form, add a pinhead of oil of cloves; they should disappear. When it is ready, the gesso should look like thick cream.*

1. Break up a small amount of gesso into a small container. Wash your hands after handling gesso as it contains lead, which is poisonous. Never put food in anything which has contained gesso.

2. Tilt the jar and add two drops of distilled water to cover the gesso. Leave the jar in this position for at least an hour – preferably overnight – to allow the water to reconstitute the gesso.

Zodiac sign for Taurus

This miniature on vellum can also be done on paper, using gesso in the same way. Tracing down with carbon can mark the vellum; make a carbon by rubbing Armenian bole on the tracing paper instead. This method will deposit a faint red line, which can be removed by dusting away with a brush or cotton wool. An eraser will remove stubborn marks, but may smudge.

YOU WILL NEED

Gesso (see opposite)
Fine pen
Vellum
Transfer gold and loose leaf gold
Tweezers
Scissors
Scalpel or knife
Glassine paper
Agate burnisher
Large, soft brush
Brushes Nos. 0, 00, 0000 and 2
Paints: watercolour and gouache

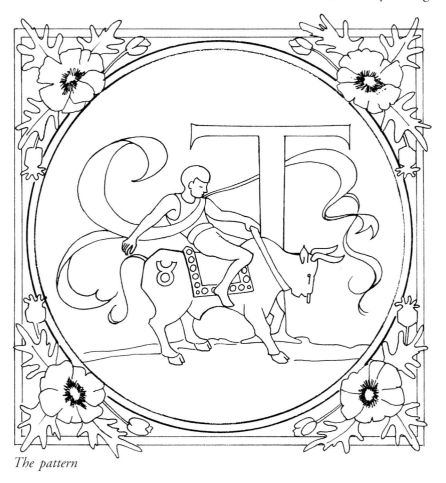

The pattern

1. Lightly prepare the vellum (see page 22). Trace the design on to the vellum using carbon paper made by coating tracing paper with Armenian bole. Outline with a fine pen using diluted red ochre watercolour paint.

2. Mask the areas you will not be gilding to protect them from grease and dirt. To apply the gesso, load it on to a brush and pull rather than 'paint' it on. Work continuously and avoid 'patching' areas.

3. Leave your work to dry, preferably overnight. Inspect for rough areas, which can be scraped smooth with a scalpel or a knife with a curved blade. Do this over a piece of paper which can be thrown away. Do not blow the gesso dust into the air as it is poisonous.

4. At this stage, the gesso can be burnished with an old burnisher or an agate stone, which will make the surface smoother and the gold brighter. When you are ready to gild, secure the vellum to the glass (see step 3, page 64) with tape.

5. Take a paper tube and exhale on the gesso to revive the glue (see page 64). The glass helps to condense the warm breath and make the gesso sticky. Apply the transfer gold and press down very firmly with your finger.

6. Repeat the process two or three times, gradually covering the letter in gold. Place glassine paper on the gold letter and press firmly with your finger to ensure that all the gold has adhered to the gesso. Brush away any excess.

7. Lay glassine paper on your design. Polish on top of the paper with an agate burnisher.

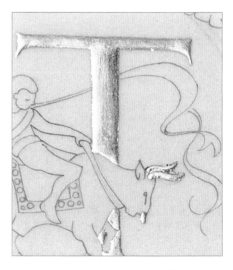

8. When the transfer gold has been completed, you can carry out a final burnish directly on to the gold, but be very careful not to scratch it.

9. For an even brighter gold effect, loose leaf gold can be applied on top of the transfer gold. Holding the book of leaves by the spine, open the last page. With clean scissors, cut out a small piece of gold and its backing sheet – about 12mm (half an inch) square.

10. Pick up the piece of gold and its backing sheet carefully at the corner – you can use tweezers. Exhale through a paper tube on the gilded letter as before.

11. Lay the gold on your design and remove the backing paper. Place glassine paper over the top and press firmly through the paper.

12. Fold back any overlapping gold onto itself with a clean brush and press down through the glassine paper.

13. Repeat steps 9–11 until the whole area has been gilded. The more layers of gold you apply, the brighter the shine. Brush away any excess gold and burnish through the glassine paper. Leave your work to dry thoroughly, preferably for 12 hours.

14. Burnish directly on top of the gold to make it really brilliant. Begin very gently at first, then gradually apply more pressure.

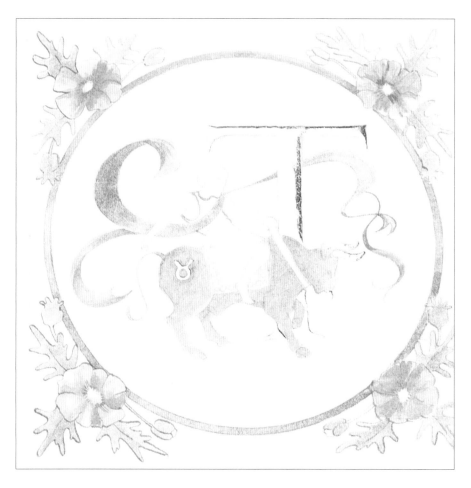

15. Using a No. 2 brush, establish the colours with a watercolour base wash. Use permanent rose and cadmium red for the flowers; a mix of Winsor green and cerulean blue with a touch of cadmium red for the leaves, and a mix of burnt sienna and ultramarine for brown tones. Allow to dry.

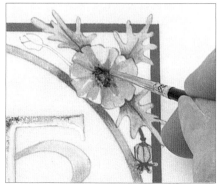

16. Change to gouache paint and begin to build up the colour using small strokes. Paint the border.

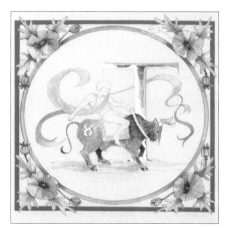

17. Build up the colour over the whole design, using cadmium and alizarin red, cobalt and ultramarine blue, permanent green and lemon yellow. With small brush strokes, paint the bull using a mix of burnt sienna and ultramarine blue. Mix the main colours; add burnt sienna or dark colours for shading, or zinc white for tints and highlights.

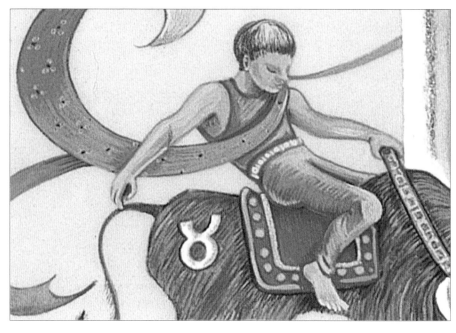

18. Paint the figure. Use burnt sienna with a trace of ultramarine for hair. The skin colour can be made with a careful mix of alizarin crimson and yellow ochre; for highlights add cadmium yellow and a small amount of permanent white and mix in cobalt blue to add shadows. Paint in the dots and designs on the saddle, reins and ribbons using a No. 0000 brush.

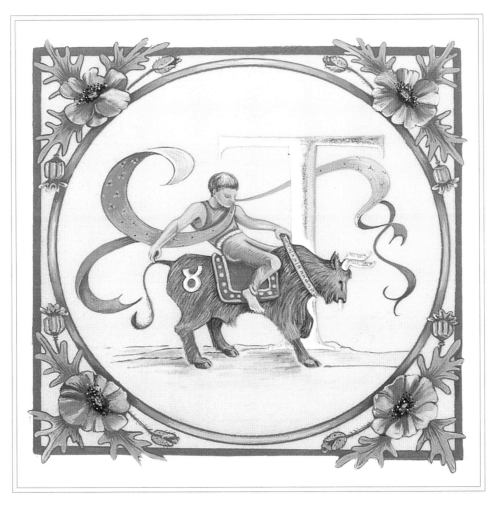

The finished miniature
*Final details like the small hairs on the flower stems and the
buds and highlights on individual leaves have been added*

Variations

These modern decorative letters can be used by themselves, with calligraphic text, or as part of a design.

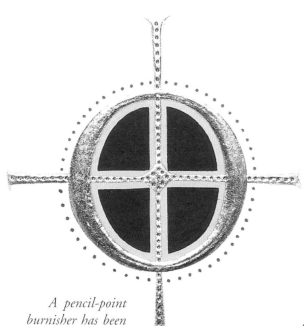

A pencil-point burnisher has been pressed into the centre cross shape to add to the decorative detail.

Calligraphically written R. The spaces are painted in gold gouache.

A pen-written B decorated with raised gold lozenges on PVA size with a pencil-point burnisher (see page 61) pressed into the gold to add to the design.

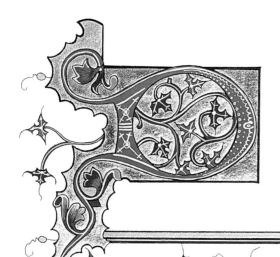

Intricately-decorated D with raised gold background and traditional ivy pattern border.

Raised gold Z with flat gold background and transfer gold on ammoniac size.

Simple gold letter based on a 14th-century design.

This letter was drawn quickly with a fine pen, and the spaces filled with gouache colour and shell gold.

A single leaf has been repeated to form a border design.

Gilded monogram on raised PVA. The letter spaces are filled with colour and pattern.

Gallery

This section is included to provide inspiration and to demonstrate the wonderful diversity of decoration and illumination. Among the illustrations featured are copies of historical manuscript letters, modern interpretations based on historical models, and original new designs. Also included are examples of miniatures, which developed from illuminated lettering to become illustrations in their own right.

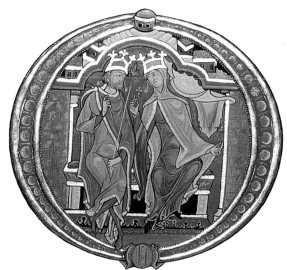

Miniature on vellum
Jan Pickett

Raised gold on gesso, painted in traditional egg tempera, copied from the Song of Solomon in the Winchester Bible

Miniature from A Little Book of Pheasants
Liz Burch

Gold on gum ammoniac, painted in gouache on HP paper.

Celtic knotwork square
Margaret Morgan

Gouache on HP watercolour paper; gilding on gum ammoniac with indented dots.

Decorative letters
Jan Pickett

The letters, taken from her own alphabet book, are gilded on a gouache background

Alphabet
Sylvia Thomas

Gold writing on blue background.

Daisy miniature
Penny Price

Gold leaf on gesso.

Illuminated letter J
Tim Noad

*Raised gold on gesso and powder gold;
gouache applied with a sponge over
masking fluid on vellum*

The Rose
Helen White

*Miniature in shell gold and gouache on vellum
featuring typical Burgundian costume c. 1430.*

G is for Grebe
Brian Walker

*Letter written with a bagpipe reed then
overwritten with gouache and gold.*

Samplers Ancient and Modern

Alan Quincey

*The same letters were rendered in different ways using
watercolour, gouache and a variety of gilding principles.
Four different metal leaves were used: transfer and loose
leaf yellow gold, white gold and palladium.*

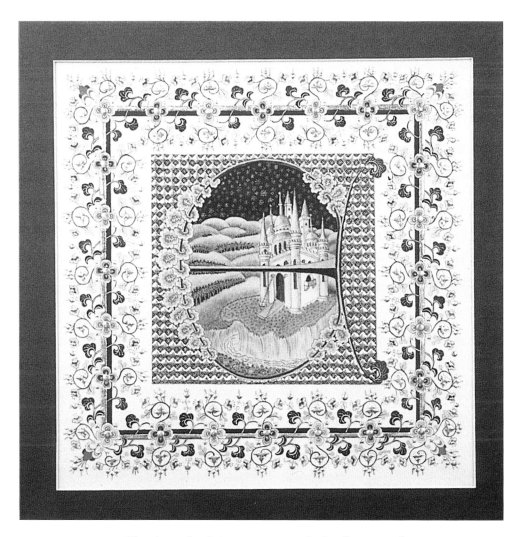

Illuminated miniature on stretched vellum panel
Lorna Banbury

Raised gold laid on gesso, painted using traditional skills.

Alphabet letters
Jan Pickett

*The background design was made by pressing on flat gold with
a pencil burnisher to create a line effect*

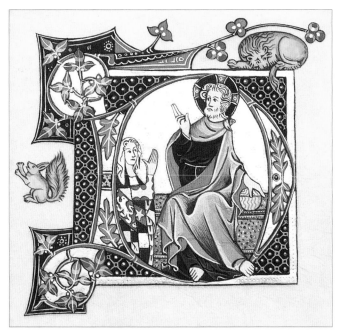

Initial D on vellum panel
Timothy Noad

Raised gold and gouache with a rich Gothic diaper background in red and blue, copied from the Grey-Fitzpayn Book of Hours

Initial E
Liz Burch

Raised and burnished gold which is tooled, with a painted background of leaves and woodland birds.

Letter R
Margaret Morgan

Written with ruling pen over a background of watercolour pencil, with gold leaf border and decoration on PVA.

94